Impressionism

Page 4:
Ladies in the Garden
Claude Monet, 1866
Oil on canvas
Musée d'Orsay, Paris

Designed by :
Baseline Co Ltd
19-25 Nguyen Hue
Bitexco Building, Floor 11
District 1, Ho Chi Minh City
Vietnam

ISBN 1-84013-730-4

Published in 2005 by Grange Books
an imprint of Grange Books Plc
The Grange Kingsnorth Industrial Estate
Hoo, nr Rochester, Kent ME3 9ND
www.grangebooks.co.uk

Printed in China

2

Foreword

"Never before have paintings appeared to me to possess such an overwhelming dignity. One can almost hear the inner voices of the earth and sense the trees burgeoning."

– Emile Zola, on Camille Pissarro

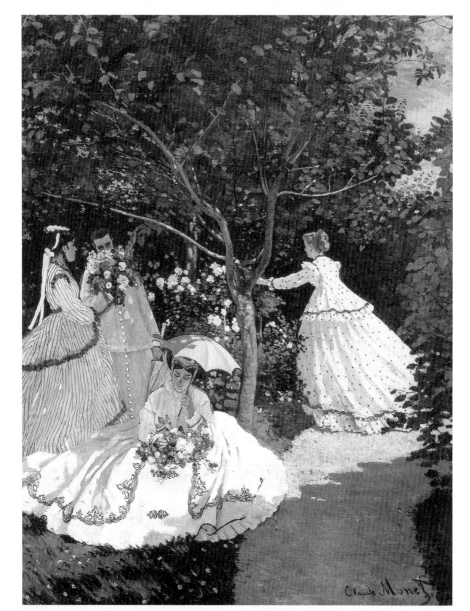

Contents

Degas

Berthe Morisot

Renoir

Claude Monet

Sisley

*I*mpression, Sunrise. (*Soleil levant,* Musée Marmottan, Paris) was the name of one of the paintings that Claude Monet displayed in 1874 at the first exhibition of the "Society of anonymous painters, sculptors, engravers, etc." It is a landscape painted early in the morning.

In the Garden, under the Trees
Le Moulin de la Galette

Auguste Renoir
Oil on canvas, 81 x 65 cm
Pushkin Museum of Fine Arts, Moscow

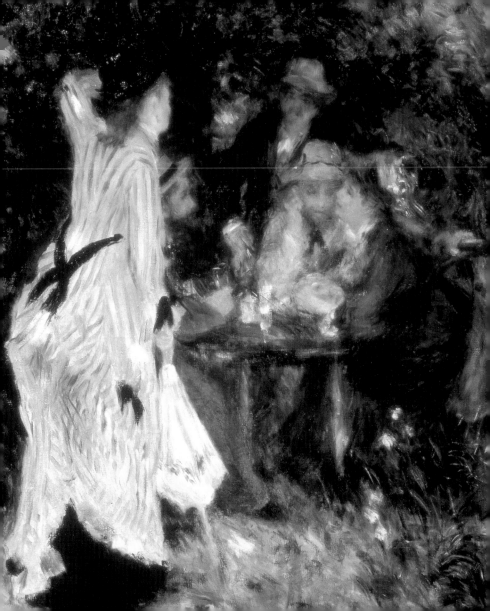

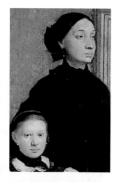

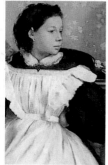

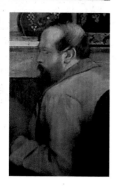

The grey mist turns the shapes of the ships' sails into ghosts; the black silhouettes of the boats slide over water, and the sun is coming up as a flat orange disc, which traces its orange path on the surface of the water. It was not exactly a painting, but rather a quick sketch, a free draft in oil.

The Bellelli Family

Edgar Degas, 1858-67
Oil on canvas, 200 x 250 cm
Musée d'Orsay, Paris

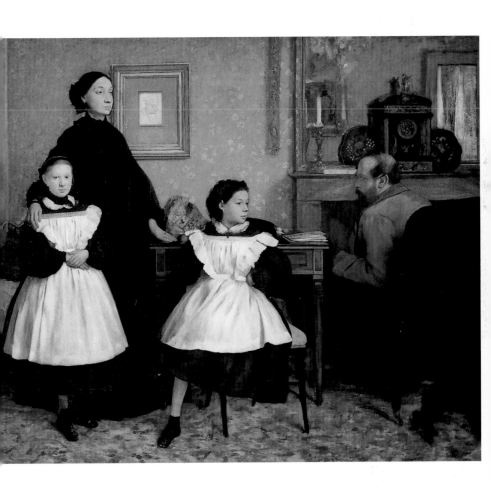

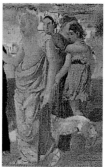

The painting's name, *The View of Le Havre,* did not really correspond to the painting – one cannot see Le Havre in it at all. "Call it *Impression*", Monet told Renoir, who was compiling the catalogue, and this was the beginning of the history of Impressionism.

Young Spartan Girls Challenging the Boys

Edgar Degas, ca. 1860
Pencil on paper, 22.9 x 36 cm
Musée d'Orsay, Paris

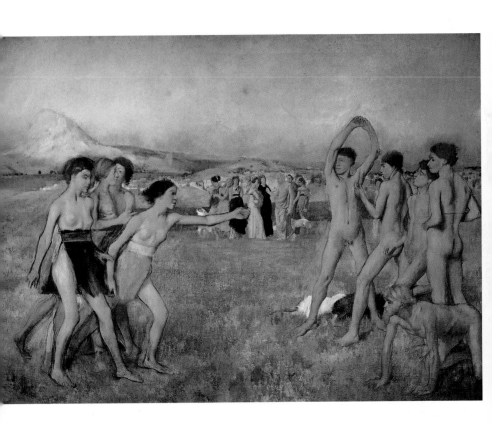

On 25 April, 1874 the critic Louis Leroy published a satirical piece in the *Charivari* newspaper, which narrated his visit to the exhibition. The surface of the work by Camille Pissarro depicting a ploughed field appeared to him to be scraped dried paint from the palette thrown onto a dirty canvas.

Self-Portrait
———
Edgar Degas, ca. 1863
Oil on canvas, 92.1 x 66.5 cm
Calouste Gulbenkian Foundation, Lisbon

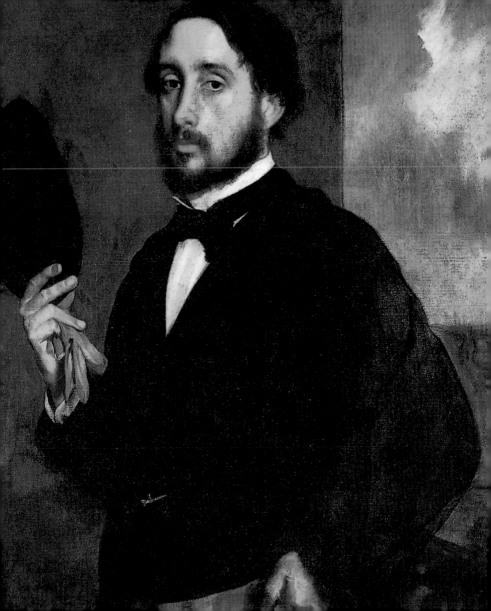

He was terrified by Claude Monet's Paris scene entitled *Boulevard des Capucines*. He stopped in front of the landscape from Le Havre painted by Monet and asked what the painting meant. *Impression, Sunrise.* "Impression!" the journalist snorted.

Bunch of Peonies

Edouard Manet, 1864
Oil on canvas, 93 x 70 cm
Musée d'Orsay, Paris

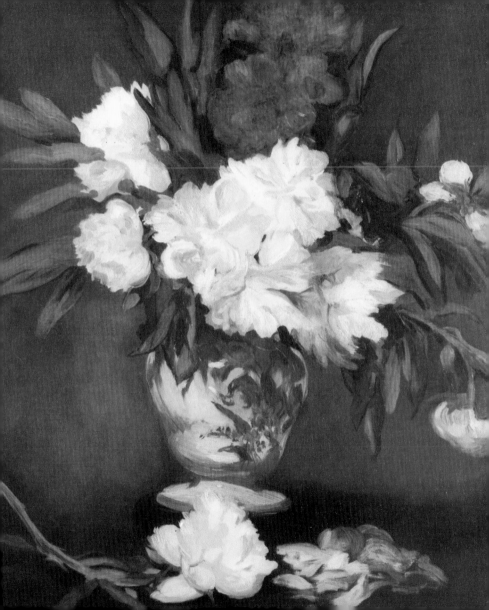

"Wallpaper in its embryonic state is more finished!" (*Charivari*, 25 April, 1874). Leroy named his article, 'The Exhibition of the Impressionists'. With a truly French linguistic agility, he coined a new word from the title of the painting. Within a year, the name "Impressionism" was an accepted term – the art itself was not.

Garden of the Princess

Claude Monet, 1867
Oil on canvas, 91 x 62 cm
Allen Memorial Art Museum, Oberlin, Ohio

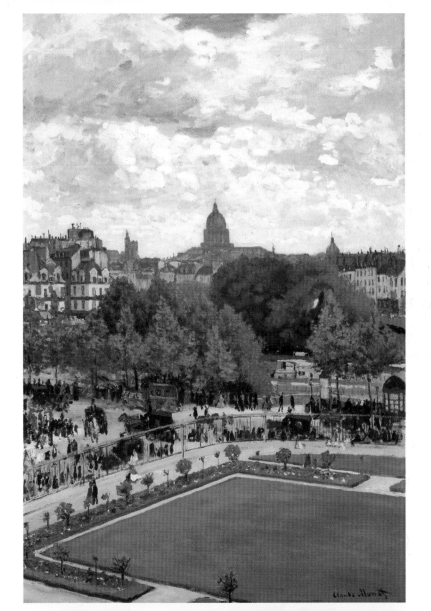

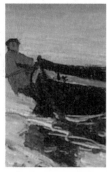

The term turned out to be so accurate that it was destined to stay forever in the history of art. The group of the future Impressionists had been formed in the early 1860s; and the term "Impressionism" came to mean a trend not only in French art, but in fact, it also was a new stage of the development of European art. It marked the end of the classical period that began in the Renaissance.

The Towing of a Boat in Honfleur

Claude Monet, 1864
Oil on canvas, 55.2 x 82.1 cm
Memorial Art Gallery of the
University of Rochester, New York

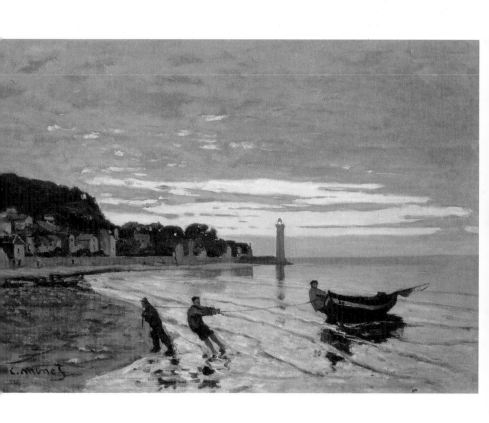

The Impressionist movement, thought, did not impose itself as an evidence. It initiated very serious discussions and criticism. It is true that the Impressionists marked an important distance with the classical school of art and this could only cause debate. The difficulty, for the Impressionists, to display their works illustrate the tension that accompanied the birth of this artistic movement.

Le Pavé de Chailly dans
la Forêt de Fontainebleau

Claude Monet, 1865
Oil on canvas, 97 x 130 cm
Ordrupgaardsamlingen, Copenhagen

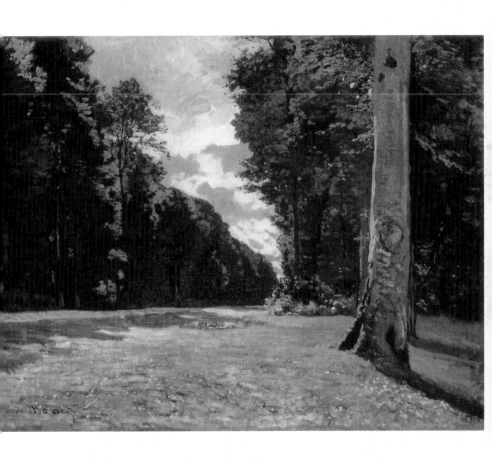

For instance, Albert Wolff, a critic, wrote after the second Impressionist exhibition: "Try to make Monsieur Pissarro understand that these trees are not violet, that the sky is not the colour of fresh butter (…) and that no sensible human being could countenance such aberrations (…) try to explain to Mr. Renoir that a woman's torso is not a mass of decomposing flesh with those purplish-green stains".

Scene of War in the Middle Ages or
The Misfortunes of the Town of Orléans

Edgar Degas, 1865
Oil on paper mounted on canvas, 81 x 147 cm
Musée d'Orsay, Paris

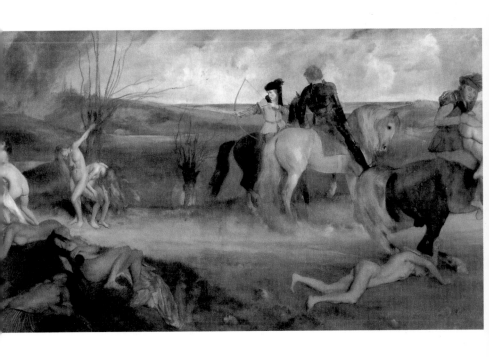

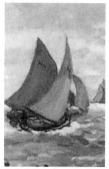

The Impressionists
and the classical school of Art

As said before, the group of young artists – the future Impressionists –, was formed in the early 1860s. Claude Monet, the son of a store owner from Le Havre, Frédéric Bazille, the son of wealthy parents from Montpellier, Alfred Sisley, a young Englishman born in France, and Auguste Renoir, the son of a Parisian tailor, all came to study painting in the free studio of professor Charles Gleyre in 1862.

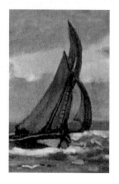

Mouth of the Seine River in Honfleur

Claude Monet, 1865
Oil on canvas, 89.5 x 150.5 cm
The Norton Simon Museum, Pasadena (California)

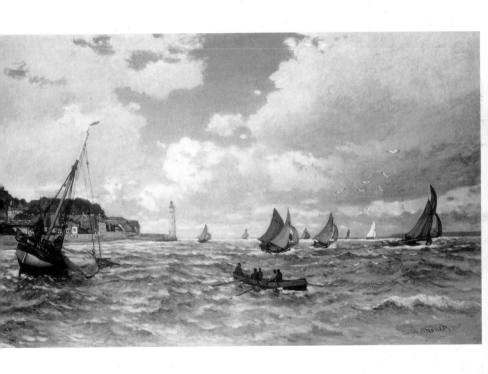

For them, Gleyre was the embodiment of the classical school of art. At the time he met the future Impressionists, Charles Gleyre was sixty years old. Born in Switzerland, on the shore of Lake Lean, he had lived in France since his childhood. Having graduated from the School of Fine Arts, Gleyre spent six years in Italy.

Avenue of Chestnut
Trees near La Celle-Saint-Cloud

Alfred Sisley, 1865
Oil on canvas, 129.5 x 208 cm
Musée du Petit Palais, Paris

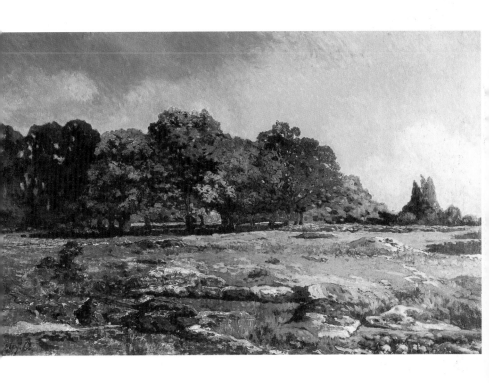

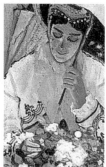

His success in the Paris Salon made him famous. Gleyre taught in the studio organized by the famous salon artist Hippolyte Delaroche. The professor painted huge pieces based on themes from the Holy Scriptures and ancient mythology built with classical clarity. The modeling of his feminine nudes could only be compared to works of the great Jean-Auguste-Dominique Ingres.

Women in the Garden

Claude Monet, 1866
Oil on canvas, 256 x 208 cm
Musée d'Orsay, Paris

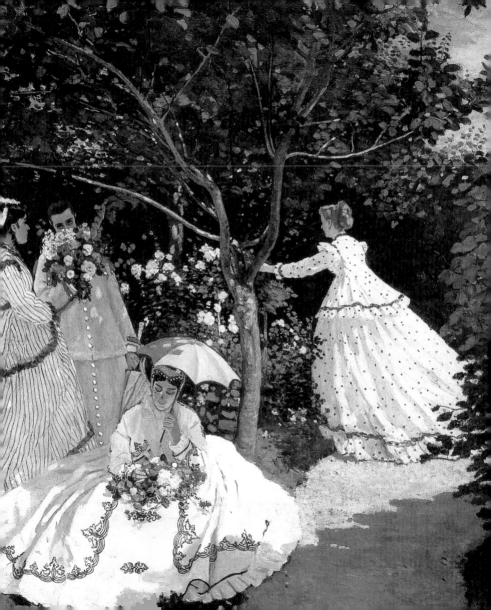

Auguste Renoir, in his conversations with his son, the great movie director Jean Renoir, said that the best part of his education took place in the studio. He described his professor as "a powerful Swiss, bearded and short-sighted" (Jean Renoir, *Pierre-Auguste Renoir, my father,* Paris, Gallimard, 1981, p.114).

Boats in the Port of Honfleur

Claude Monet, 1866
Oil on canvas, 49 x 65 cm
Private collection

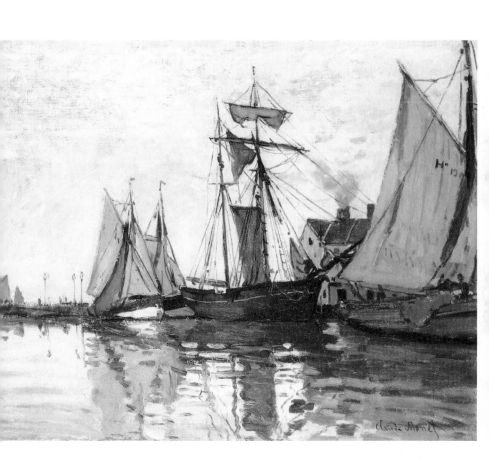

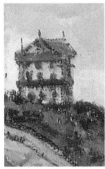

According to Renoir, the studio that was located in the Latin Quarter on the left bank of the Seine was "a big bare room, filled with young people leaning on their easels. To the north, a bay window enabled grey light to pour in over the objects under observation" (op. cit. and loc. cit.). The students were all very different.

Beach at Sainte-Adresse

Claude Monet, 1908
Oil on canvas, 75.8 x 102.5 cm
Art Institute of Chicago

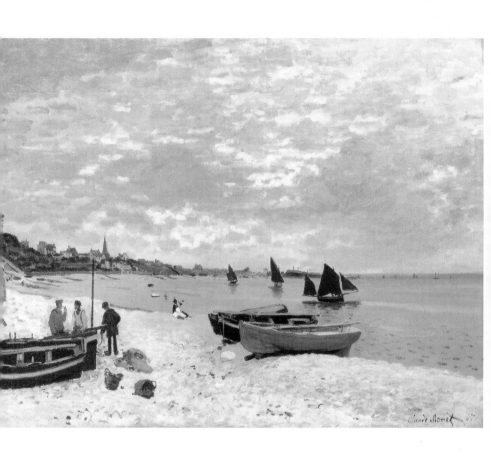

Young men from rich families who "played artists" came to the studio in black velvet jackets and berets. Claude Monet called this bourgeois group of students – 'the spices'. A white painter's blouse worn by Renoir fuelled their mockery, but Renoir, just like his new friends, ignored them.

Lady in the Garden (Sainte-Adresse)

Claude Monet, 1867
Oil on canvas, 80 x 99 cm
The Hermitage, Saint-Petersburg

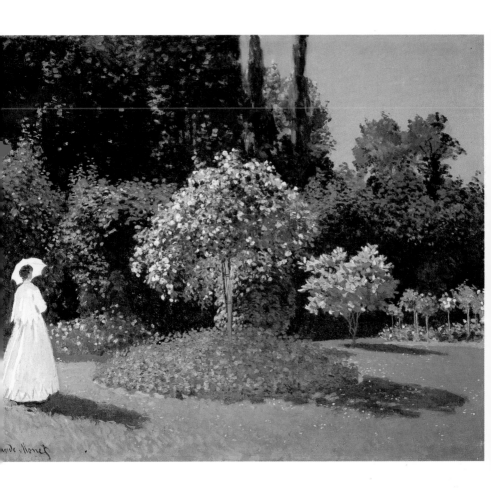

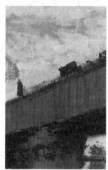

Jean Renoir wrote, "he was there to learn how to draw figures. He quickly covered his paper with charcoal lines and, the drawing of a calf or the curve of a hand completely absorbed him" (op. cit., p.114). For Renoir and his friends, these lessons were not a game, although Gleyre was bewildered by the amazing skill with which Renoir worked.

The Railway Bridge, Argenteuil

Claude Monet, 1873
Oil on canvas, 54 x 71 cm
Musée d'Orsay, Paris

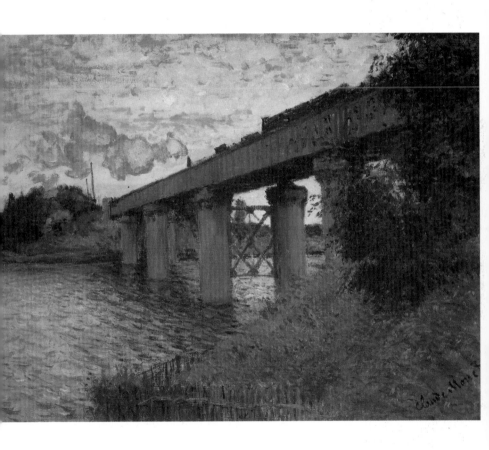

Renoir imitated his professor's reproaches with that amusing Swiss accent which made students laugh, "young man, you are very skillful, very talented, but one says you come for fun – It is evident, my father responds" Jean Renoir wrote, "if it did not amuse me, I would not paint!" (Jean Renoir, op. cit., p.119).

The Cliff at Dieppe

Claude Monet, 1882
Oil on canvas, 65 x 81 cm
Kunsthaus Zürich, Zürich

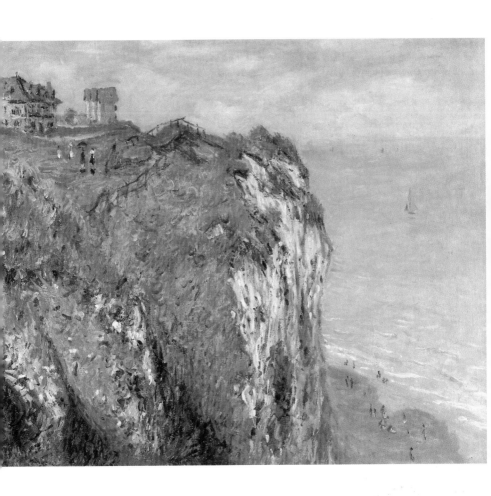

In this studio, the students learned traditional classical education freed from the form requirements of the French Academy of Fine Arts. The four future Impressionists were seriously inclined to learn the basics of painting and the classical technique. They tediously studied the nudes and took all the mandatory courses winning awards for drawing, perspective, anatomy, and precision.

Portrait of Madame Gaudibert

Claude Monet, 1868
Oil on canvas, 217 x 138 cm
Musée d'Orsay, Paris

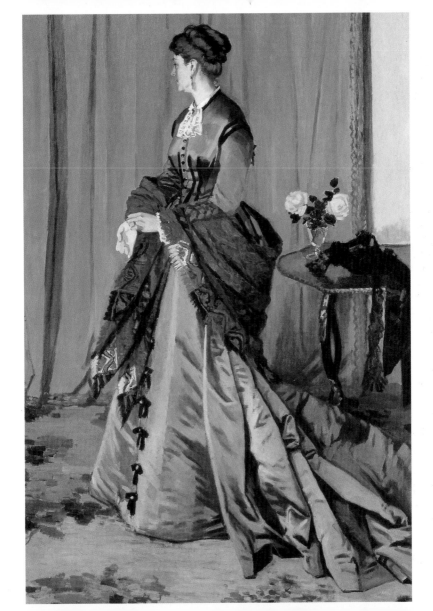

They acquired the essential knowledge of technique and technology of painting, the mastery of the classical composition, precision of the drawing and the beauty of the line, although later the critics frequently mocked the Impressionists for what they regarded as the lack of these very skills. All of the future Impressionists would receive praise from their teacher from time to time.

Snowy Landscape

Auguste Renoir, 1868
Oil on canvas, 51 x 66 cm
Musée de l'Orangerie, Paris

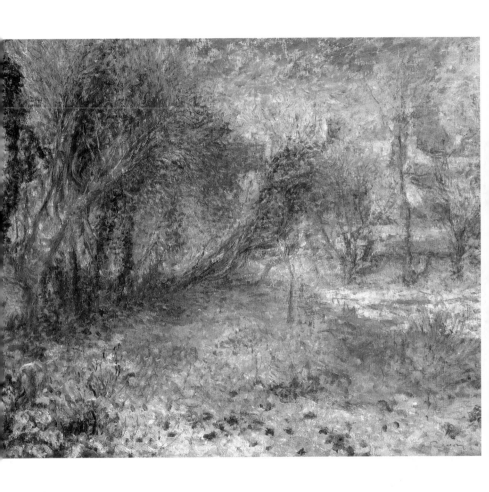

One day, to please the professor, Renoir painted a nude model following all the rules, as he would say, "a caramel-coloured flesh emerges from asphalt, black like the night, a caressing backlight which highlights the shoulder, the tortured expression that accompanies the stomach cramps" (J. Renoir, op. cit., p.119).

Interior

Edgar Degas, ca. 1868-69
Oil on canvas, 81 x 116 cm
Philadelphia Museum of Art, Philadelphia

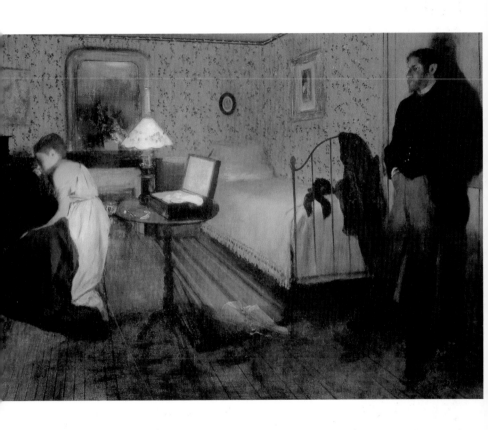

Gleyre considered this to be mockery. His surprise and outrage were not accidental, for the student proved that he could wonderfully paint according to the teacher's requirements while at the same time all these young people tried to paint their models "in their day-to-day state" (J. Renoir, op. cit., p.120).

Pouting

Edgar Degas, ca. 1869-71
Oil on canvas, 32.4 x 46.4 cm
The Metropolitan Museum of Art
New York. H.O. Havemeyer collection

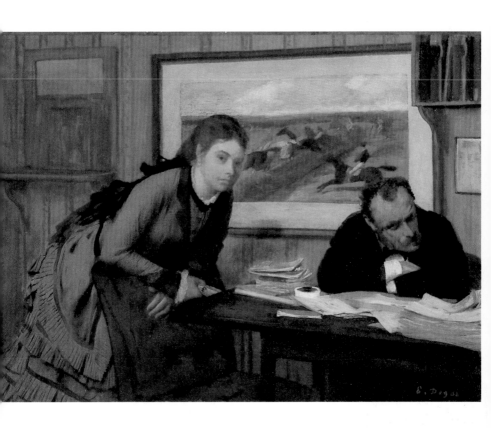

49

Monet recalled Gleyre's reaction to his sketch of a nude model: "not bad," he wrote himself, "not bad at all. But it is too much in the character of the models. You have a stocky man. He has enormous feet, you draw them as they are. All that is very ugly. Remember young man that when one executes a figure one should always think of the ancient style.

La Grenouillère

Claude Monet, 1869
Oil on canvas, 74.6 x 99.7 cm
The Metropolitan Museum of Art, New York

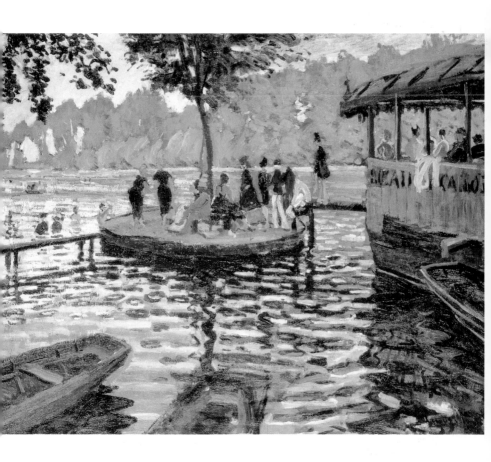

Nature, my friend, is very beautiful to study, but it does not offer originality" (François Daulte, *Frédéric Bazille*, Pierre Cailler, Geneva, 1952, p.30). But for the future Impressionists, it was precisely nature which offered originality.

La Grenouillère

Auguste Renoir, 1869
Oil on canvas, 66 x 81 cm
Statens Konstmuseert, Stockholm

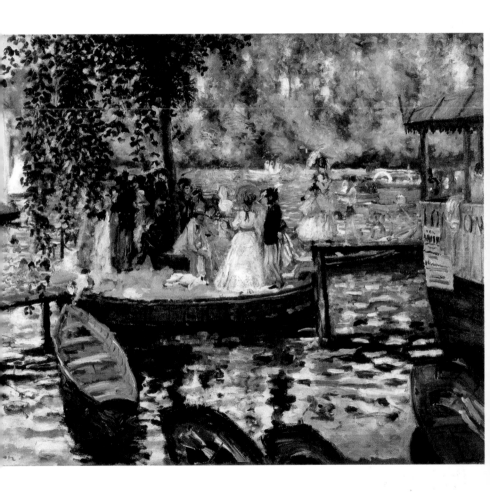

Renoir reported that in their first meeting, Frédéric Bazille told him, "the big, classical compositions are finished. The depiction of daily life is more fascinating" (J. Renoir, op. cit., p.115). They all gave preference to live nature and were outraged by Gleyre's disdain to landscapes.

Lady's Cove

Alfred Sisley, 1897
Oil on canvas, 65.5 x 81.2 cm
Private collection

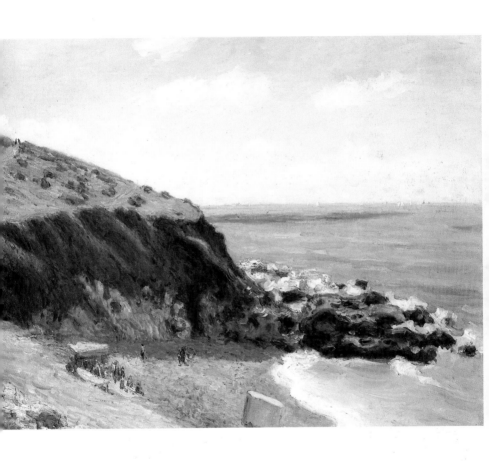

It nevertheless was difficult to complain about any kind of constraint in Gleyre's studio. This education included the study of ancient sculpture, paintings by Raphael and Ingres in the Louvre. In fact, Gleyre's pupils were completely free. Still, Monet, Bazille, Renoir and Sisley left their instructor very early, in 1863. The rumor was that the studio was closing down because of a lack of money and the state of Gleyre's health.

Flowers in a Vase

Auguste Renoir, 1866
Oil on canvas, 81.3 x 65.1 cm
National Gallery of Art, Washington

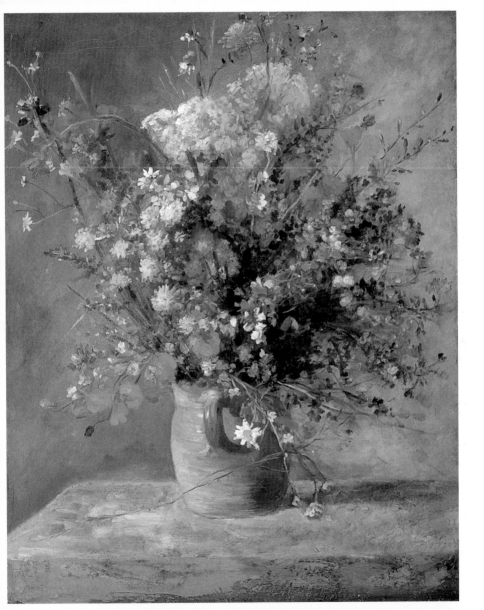

In the spring of 1863 Bazille wrote to his father, "Mr. Gleyre is quite sick, it appears that he is threatened by the loss of sight. All the students are strongly afflicted by this because he is strongly liked by those who approach him" (F. Daulte, op. cit., p. 29). But this was not the only reason why they completed their formal education. Perhaps they felt that over the time they had spent in the studio, they had acquired from their instructor everything possible.

The Bougival Bridge

Claude Monet, 1870
Oil on canvas, 56.41 x 92.39 cm
The Currier Gallery of Art
Manchester, New Hampshire

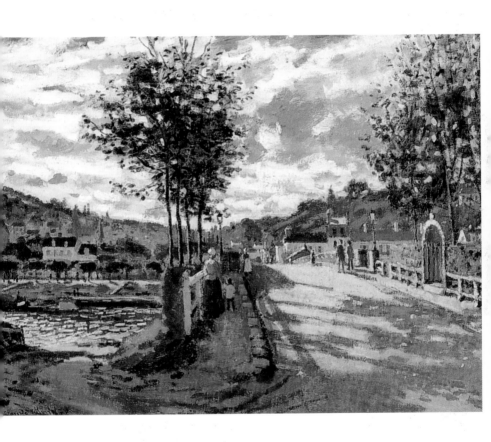

59

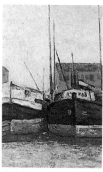

They were young and passionate. A new aesthetical idea attracted them and encouraged them to get out of the studio into the midst of actual modern life. One day, coming back from Gleyre's, Bazille, Monet, Sisley and Renoir stopped by the café 'La Closerie des Lilas', at the corner of Boulevard du Montparnasse and Avenue de l'Observatoire where they had long discussions about further ways of painting. Bazille brought a new friend of his, Camille Pissarro.

Barges

———

Alfred Sisley, ca. 1870
Oil on canvas, 69 x 100 cm
Musée de Dieppe, Dieppe

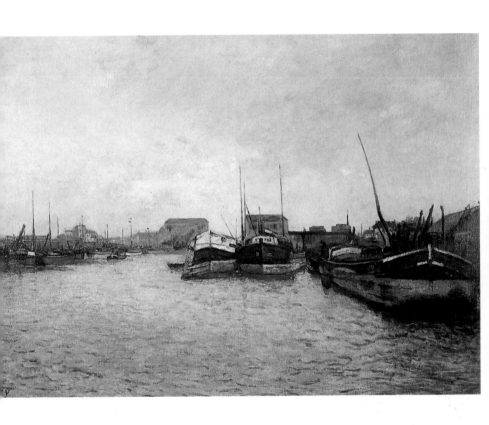

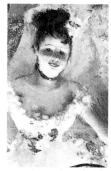

The members of this small group called themselves the "Intransigeants". Together they dreamt of a new Renaissance. Natural objects presented professional interest for the future Impressionists. Most likely a certain part in their instantaneous turn to nature was played by the appearance to the public, in the same year of 1863, of the work of Edouard Manet, *Luncheon on the Grass* (Musée d'Orsay, Paris).

Orchestral Musicians

Edgar Degas, 1870-71
Oil on canvas, 62 x 49 cm
Städtisches Kunstinstitut, Frankfurt

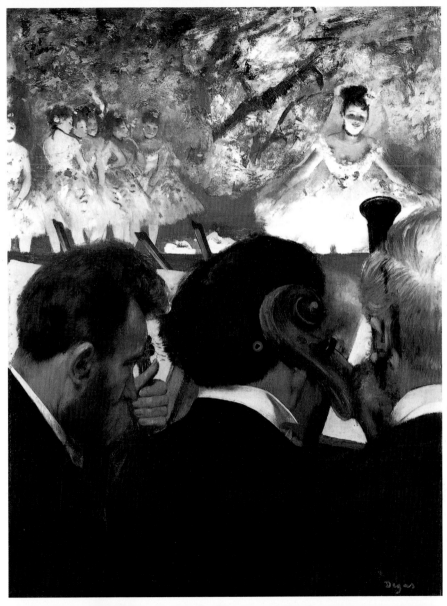

This painting impressed the young artists to the same extent as it impressed the public and the critics. Manet, who had taken the first steps away from the classical school, had already started doing what they had dreamt of. He had already turned to a more modern approach of painting. Many years later, Renoir told his son about this with excitement.

Bordeaux Harbour

Edouard Manet, 1871
Oil on canvas, 65 x 100 cm
Foundation E.G. Bührle, Zürich

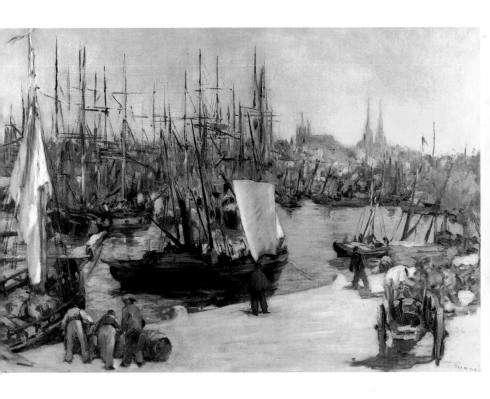

Jean Renoir wrote, "the 'Intransigeants' aspired to fix the canvases with their direct perceptions without any transposition (…). The official school, imitation of imitations of the schoolmasters, is dead. Renoir and his companions are alive. (…). The reunions of the "Intransigeants" are passionate because of their burning desires to communicate with the public, and of their will to discover the truth. The ideas burst (…). The one idea that they proposed very seriously was to burn the Louvre" (J. Renoir, op. cit., pp. 120-121).

The Flood at Port-Marly

Alfred Sisley, 1872
Oil on canvas, 50 x 65 cm
Private collection

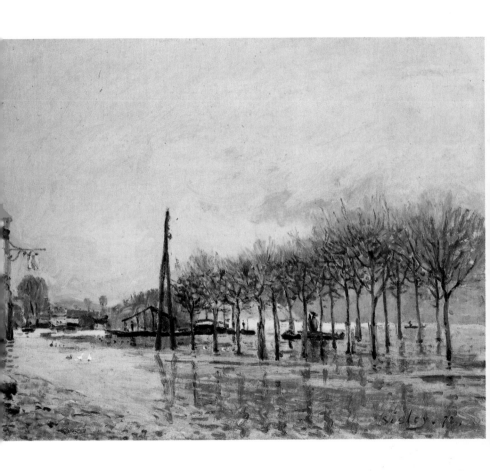

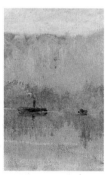

Sisley was the first one to take friends to paint landscapes in the forest of Fontainebleau. Now instead of the properly positioned nude on the podium, they studied the nature with its infinite variety of flickering, and the continuously changing greens of trees in the sunlight. Renoir said, "our discovery of nature really captured us" (J. Renoir, op. cit., p. 118). They chose the genre of landscape painting which was not related to anything else but nature.

The Seine at Bougival

Alfred Sisley, 1872
Oil on canvas, 46.5 x 65.5 cm
Musée des Beaux-Arts, Lille

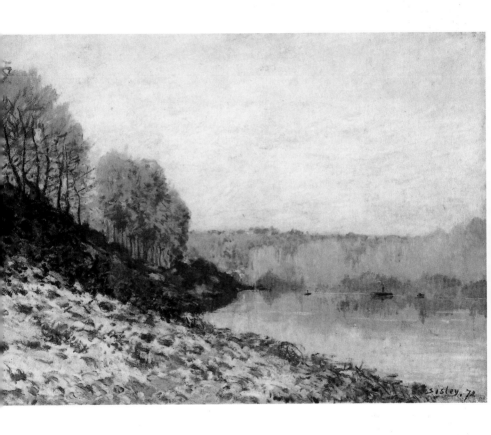

Almost all of them began their artistic career by painting landscape. The landscape genre did not call for imagination but exclusively for observation.

The new artist's view of nature was seen as the logical continuation of all previous artistic experience. According to them, the artist had to paint what he saw, rather than what he had been taught.

La Grande Rue à Argenteuil

Alfred Sisley, 1872
Oil on canvas, 65.4 x 46.2 cm
Norwich Museum Services, Norwich Castle

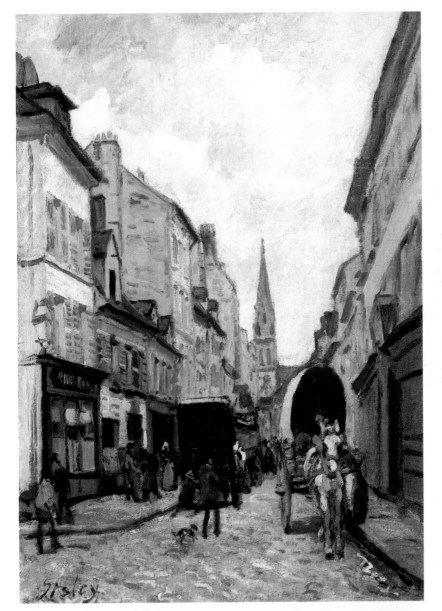

Sisley

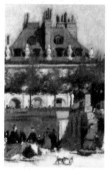

But in order to study nature, they could no longer work within the walls of their studios and so, worked outside, *en plein air* (in the open air), setting up their easels in the forest or in the middle of a field. The intent observation of nature was more powerful than ever.

If the landscape made outside from nature did not comply with the traditional notion of the painting's composition, of the transfer of perspective, then it meant that all school rules had to be discarded and nature's way had to be followed.

The Pont des Arts

Auguste Renoir, 1867
Oil on canvas, 62 x 102 cm
The Norton Simon Museum, Pasadena, California

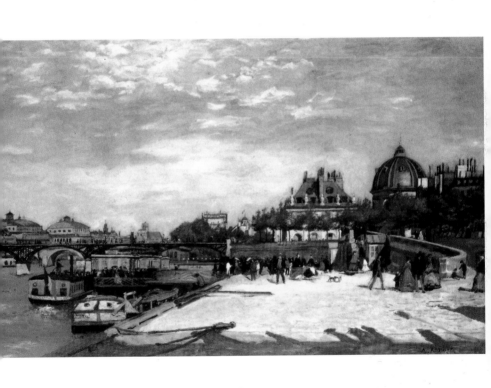

If the old artistic technique did not conform to what they observed in nature, then the technique had to be changed. A new kind of painting thus appeared in art.

It did not meet the traditional understanding of accomplishment and frequently looked more like a quick study painted in oil. However, the Impressionists did not have a new aesthetic theory that could have replaced the old one.

Woman Reading

Claude Monet, 1872
Oil on canvas, 78.7 x 60.9 cm
Walters Art Gallery, Baltimore

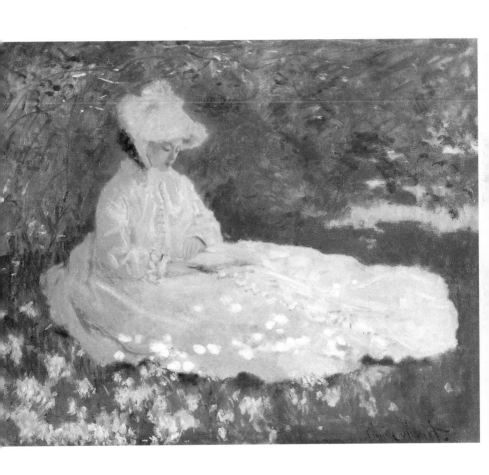

They were only seriously convinced that they could use all and any means to reach the reality in their painting. In 1877, three years after the first Impressionist exhibition, a critic wrote, "they claim, these bold ones, that one is able to do the artist's work with neither professor nor practice of religious theories, or of school and of traditional jobs (...). To

Walk on Donkeys at La Roche Guyon

Camille Pissarro, 1864-1865
Oil on canvas, 35 x 51.7 cm
Private collection

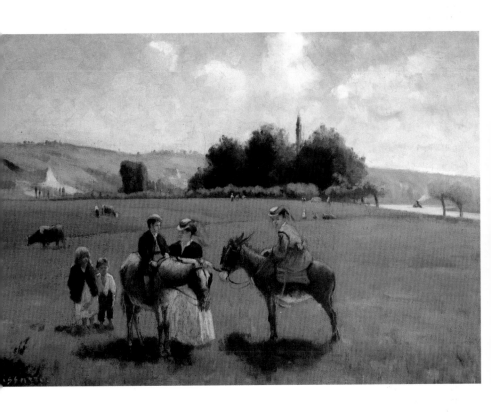

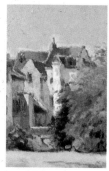

those who ask them to formulate a program, they cynically respond that they do not have a program. They satisfy themselves with giving the public artistic impressions of their minds and of their hearts, sincerely, naively, without touch-ups (…)" (Venturi, op. cit., v. 2, p.330). But the Impressionists did not completely break off with the theories of Leonardo da Vinci and the rules on which all the Art Academies in Europe had been based for over three centuries.

Pontoise, Square of the Old Cemetery

Camille Pissarro, 1872
Oil on canvas, 55.8 x 91.5 cm
Museum of Art, Carnegie Institute, Pittsburg

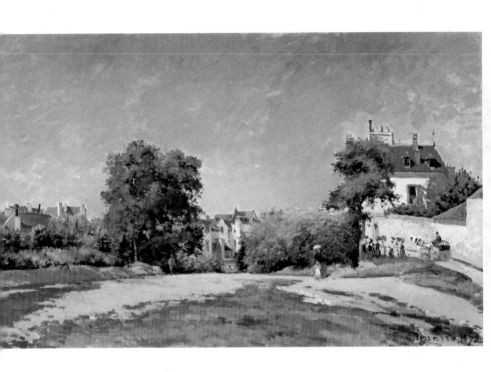

Each Impressionist studied, to a certain extent, with professors of the traditional school. Each of them had their favorite artists from the earlier periods. However, the most important point that differenciated them from the traditional school, was their view of the world and of painting. They did not question the literary aspect of painting, nor had they the need for a story, had it been historical or religious, as a foundation for their painting.

Poppies at Argenteuil
―――――――――――
Claude Monet, 1873
Oil on canvas, 50 x 65 cm
Musée d'Orsay, Paris

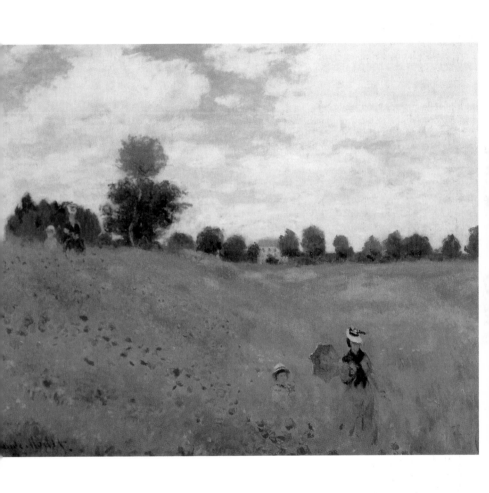

Nevertheless their intention to "burn the Louvre" was not a conviction but rather a phrase, mentioned passionately in the middle of a fervent discussion. Having been asked by his son whether he had gained anything from studying in the classical studio of Gleyre, old Renoir replied, "a lot, and despite the professors. Copying the same thing ten times, from scratch is excellent. It is boring and if you

Boulevard des Capucines

Claude Monet, 1873
Oil on canvas, 61 x 80 cm
Pushkin Museum of Fine Arts, Moscow

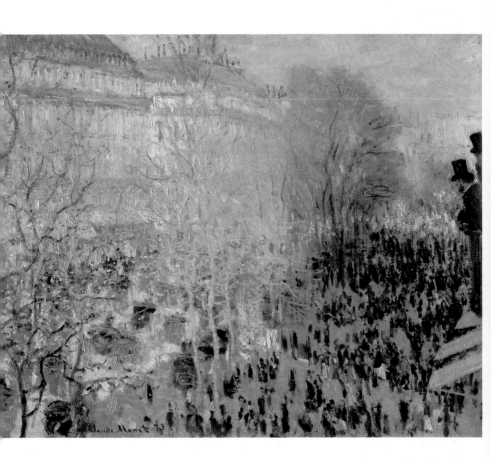

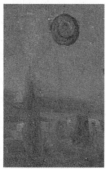

are not obliged to do it, you do not do it. But to truly learn, there is only the Louvre" (J. Renoir, op. cit., pp. 112-113). So eleven years after departing from Gleyre's studio, they worked *en plein air* and they had elaborated a new concept of painting. But the Impressionists had had artistical predecessors.

Impression, Sunrise

Claude Monet, 1873
Oil on canvas, 48 x 63 cm
Musée Marmottan, Paris

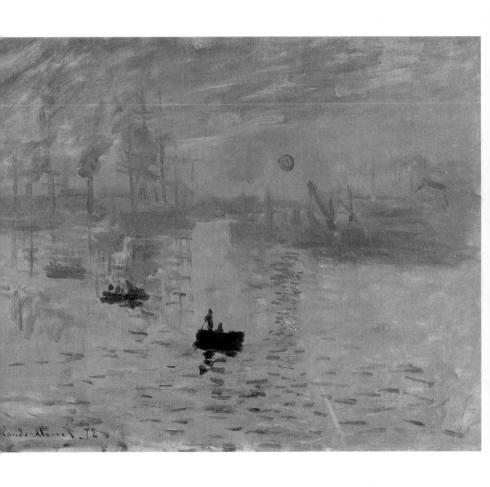

The predecessors

The "Intransigeants" were able to learn in the Louvre. The museum provided them with the richest and widest selection of masters from whose works they could learn those skills that they were searching for in painting. In fact, that was a second school for them. The eighteenth-century Venetian masters and Rubens gave them lessons about the beauty of pure colour.

The Cotton Market
<hr />
Edgar Degas, 1873
Oil on canvas, 74 x 92 cm
Musée des Beaux-Arts, Pau

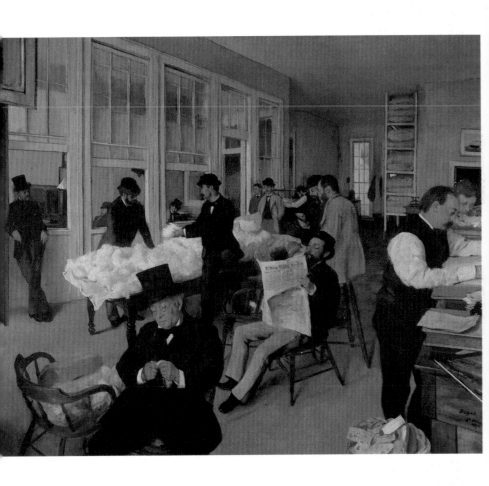

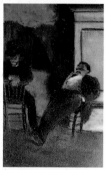

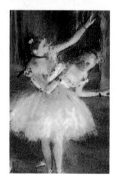

But perhaps the experience of their compatriots was the closest for the Impressionists. They did not ignore the art of Antoine Watteau. His small colourful brushstrokes, the ability to transfer with the slightest shades of colour the trepidation of nature, ultimately paid a critical part in the development of Impressionism, alongside the expressive manner of the painting of Honoré Fragonard.

The Rehearsal on Stage

Edgar Degas, 1874
Pastel over brush and on paper
55.3 x 72.3 cm
The Metropolitan Museum of Art
New York, H.O. Havemeyer collection

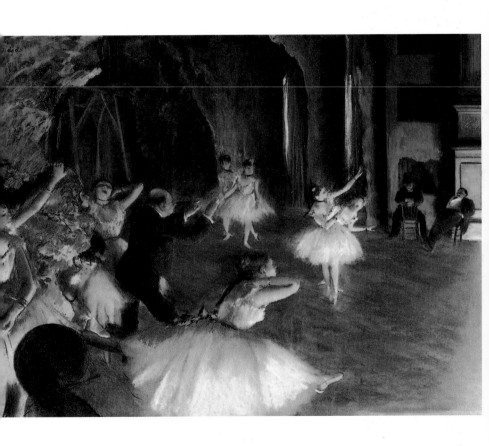

Back in the eighteenth century both artists departed from the enamel-like smoothness of the surface of the painting. The observant eye could see in their pieces how important the shape and energy of the colourful brushstroke was. They showed that these brushstrokes should not be shamefully hidden, but should become a way of reproducing nature.

The Studio Boat

Claude Monet, 1874
Oil on canvas, 50.2 x 65.5 cm
Kröller-Müller Museum
Otterlo, Netherlands

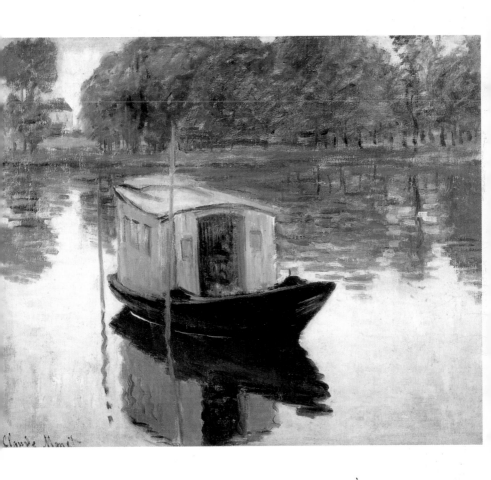

Claude Monet

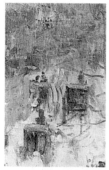

The artists who were born around 1840 entered the art already carrying the notion that even mundane daily subject matters could be painted. In the early nineteenth century, France held the most conservative position in Europe in the landscape genre.

The classical "composed" landscape was built on the basis of the study of nature's details; the study of trees, leaves, and rocks reigned at the annual Salon.

Boulevard des Capucines

Claude Monet, 1873
Oil on canvas, 79.4 x 59 cm
William Rockhill Nelson Gallery
and Atkins Museum of Fine Arts
Kansas City, Missouri, USA

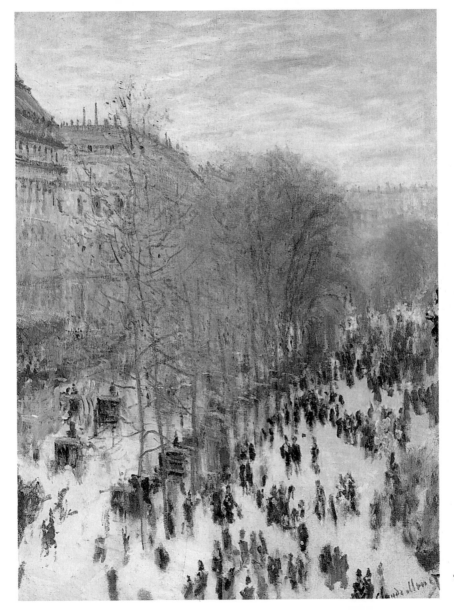

Yet, back in the eighteenth century the Dutch masters were already painting live and observed the nature of their country. Their modest, small-scale paintings showed real parts of Holland – its high sky, the frozen canals, the trees covered with hoarfrost, the windmills and the little cozy towns. With the help of colour nuance, they were able to convey the impression of the humid atmosphere of their land.

White Frost
Summer in Saint-Martin

Alfred Sisley, 1874
Oil on canvas, 46.5 x 55.5 cm
Private collection, Dublin

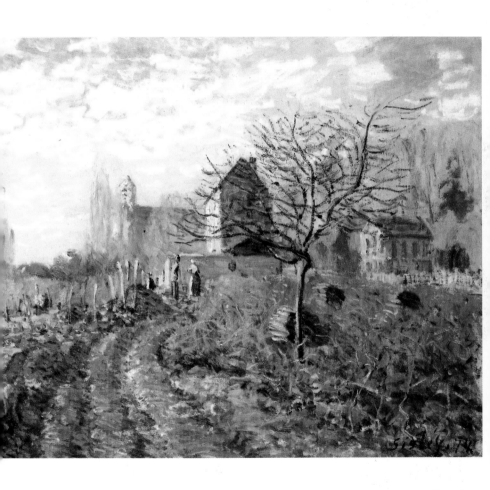

The composition of their paintings did not use any classical scenic stages. The low waterline was stretched parallel to the edge of the canvas, creating an impression of the direct look at nature. The eighteenth-century Venetian artists created a specific landscape genre – *veduto*. The paintings of Francesco Guardi, Antonio Canale, and Bernardo Belotto, composed in theatrically beautiful manner, followed all the rules of the classical school, and depicted real-life subject matters.

Hampton Court Bridge

Alfred Sisley, 1874
Oil on canvas, 46 x 61 cm
Wallraf-Richartz Museum, Cologne

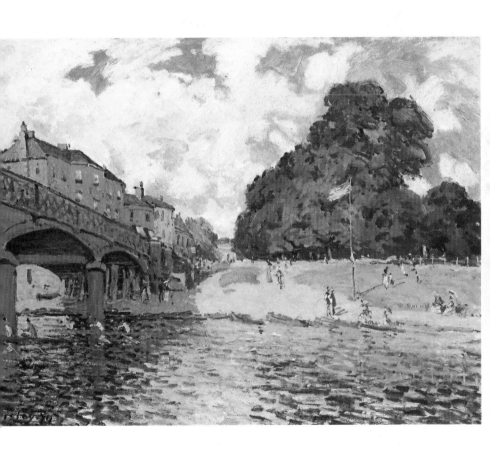

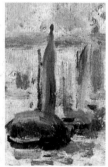

They were so peculiar and topographically correct that they are featured in the history of art as documents recording the image of the cities that are now lost in time. Moreover, the *veduto* landscapes included the light mantle of the moist mist above the Venetian lagoons and a particular transparency of the air over the Elbe. The future Impressionists also sought artists whose works had not yet made their way to the museums.

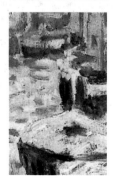

The Thames, Charing Cross Bridge

Alfred Sisley, 1874
Oil on canvas, 33 x 46 cm
Private collection, London

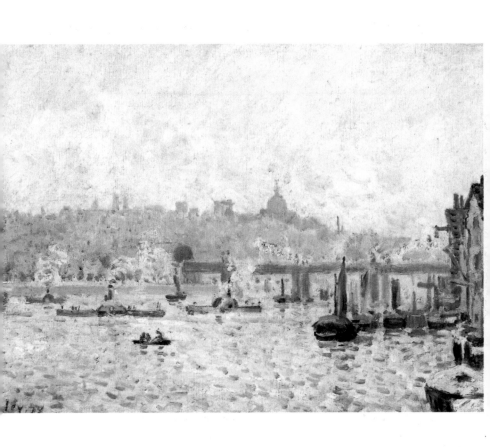

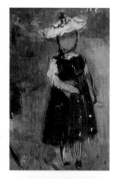

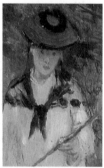

In the late eighteenth-century in England the "sketching-club" was established. The artists that joined it worked directly outdoor and specialized in light sketchy landscapes. The charm of their landscape art lied in the transparency and softness of the watercolours that transferred the impression of the air and of the refined atmosphere.

Chasing Butterflies

Berthe Morisot, 1874
Oil on canvas, 46 x 56 cm
Musée d'Orsay, Paris

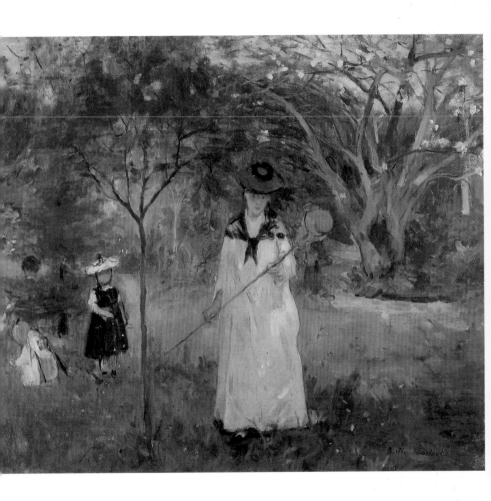

Richard Parks Bonnington, who spent most of his life in France, was a pupil of Gros and close to Delacroix. Bonnington depicted the motifs of Normandy and of Ile-de-France, locations where all the Impressionists later worked. They were also familiar with the work of the Englishman John Constable that could teach them how to perceive the landscape as a whole and how to use the expressive colourful brushstrokes.

Lilacs at Maurecourt

Berthe Morisot, 1874
Oil on canvas, 50 x 61 cm
Private collection

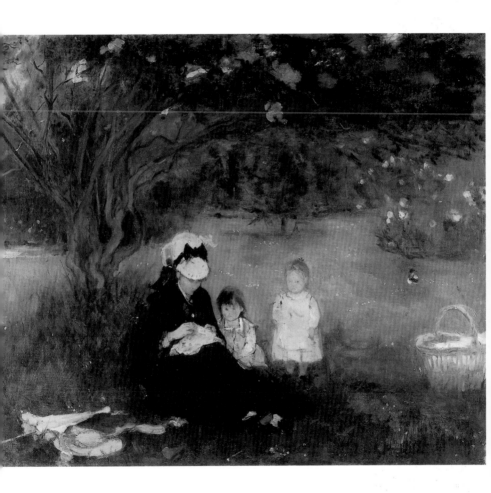

Even once finished, his paintings created the impression of sketches and maintained a freshness of colour due to the fact that they were produced outdoor. Furthermore, the Impressionists knew Joseph Turner who was the acknowledged head of the English landscape school for sixty years. Turner depicted the effects of nature.

On the Terrace

Berthe Morisot, 1874
Oil on canvas, 45 x 54 cm
Fujiart Museum, Tokyo

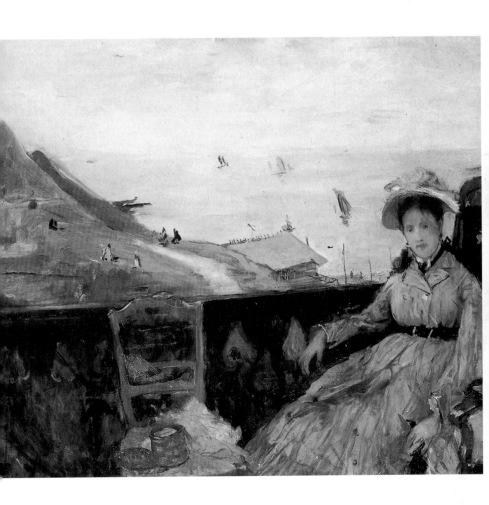

The fog, the mist at sunset, the clouds of steam coming from a train, or just a cloud in his painting were his favourite motifs. Turner painted a series of watercolours called *The Rivers of France*. He began an artistic poem dedicated to the Seine, which was later continued by the Impressionists. His series also included a landscape featuring the Rouen Cathedral, a possible precursor to the *Rouen Cathedrals* by Claude Monet.

Argenteuil

Edouard Manet, 1874
Oil on canvas, 148.9 x 115 cm
Musée des Beaux-arts, Tournai

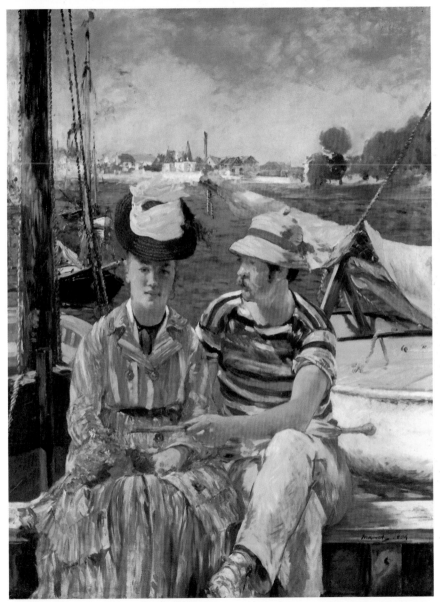

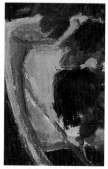

In the mid-nineteenth century, the professors of the Paris School of Fine Arts still promoted the "historical landscape". Perfect examples are the seventeenth-century paintings by Nicolas Poussin and Claude Lorrain. The Impressionists, however, were not the first ones who opposed the stereotypes and fought for realism in the aesthetic of painting.

The Barge

Claude Monet, 1887
Oil on canvas, 146 x 133 cm
Musée Marmottan, Paris

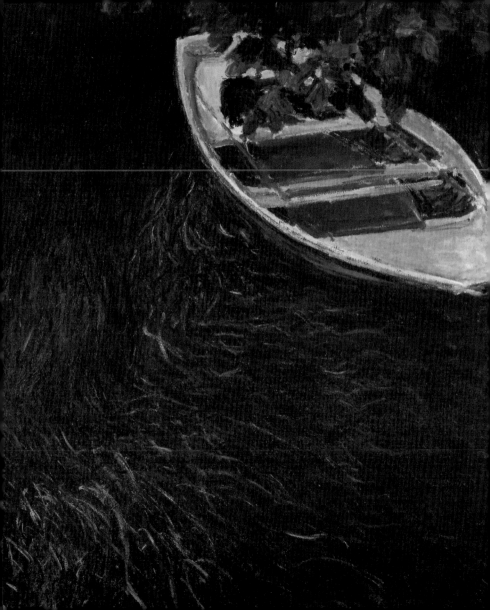

They had been preceded in their aesthetical research by painters such as those from the Barbizon group. Some of the Impressionists met painters from the Barbizon group. For instance, Auguste Renoir told his son about a strange encounter in 1863 in the forest of Fontainebleau. The sight of an artist wearing a working blouse and painting *en plein air* for some reason dissatisfied a group of young people.

Pond at Montfoucault

Camille Pissarro, 1875
Oil on canvas, 73.5 x 92.5 cm
Barber Institute of Fine Arts, Birmingham

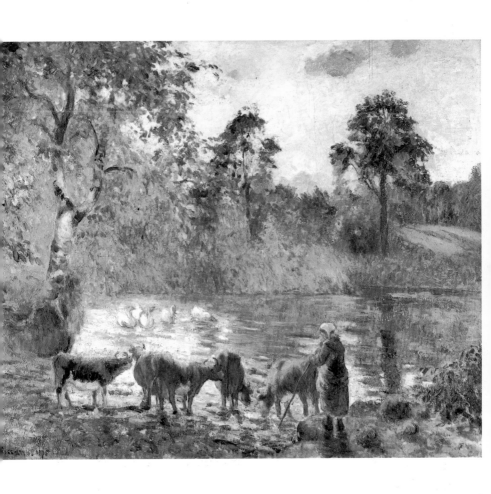

One of them kicked the palette out of Renoir's hand, and the others pushed the artist down to the ground. "They hit him with a parasol (…) in the face, with the steel tip, they could have punctured my eye! Suddenly, a man in his 50's, big and strong, emerged from a bush (…). He had a wooden leg and held a heavy cane in his hand. The newcomer got rid

Portrait of Claude Monet

Auguste Renoir, 1875
Oil on canvas, 85 x 60 cm
Musée d'Orsay, Paris

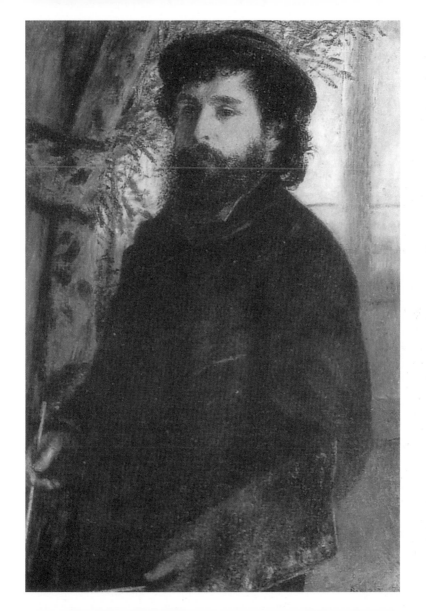

of his stuff and leapt up to assist his young colleague. With blows of his cane and a wooden leg, he acted fast to frighten away the attacker. My father got up and joined the struggle (...). Very quickly the two painters were once again masters of that territory. The one-legged man, without listening to the thanks of his colleague, collected his canvases and looked at him attentively. Not bad at all. You are gifted, very gifted" (...).

The Walk
Woman with a Parasol

Claude Monet, 1875
Oil on canvas, 100 x 81 cm
National Gallery of Art, Washington DC

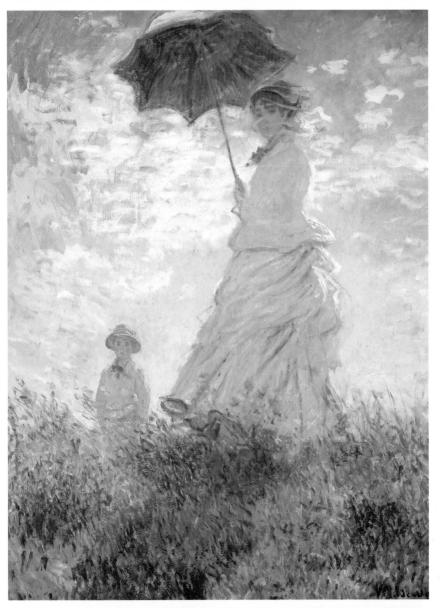

The two men sat down on the grass and Renoir related his life and his modest ambitions. The man in turn presented himself. "I am Diaz" (Jean Renoir, *Pierre-Auguste Renoir, my father*, Paris, Gallimard, 1981, p. 82-83). Narcisse Virgile Diaz de la Pea had been a member of the so-called Barbizon group of landscapists, a generation of artists who were born in the late 1810s and in the early 1820s.

Near the Fireplace

Auguste Renoir, 1875
Oil on canvas, 61.5 x 50.6 cm
Staatsgalerie, Stuttgart

The members of this group lived almost half a century before the Impressionists. The Barbizon artists were the first ones to paint landscapes outdoor. It was, therefore, not surprising that the encounter of Renoir and Diaz took place in the forest of Fontainebleau. The Barbizon artists learned from the traditional classical school of landscape, but in the early 1830s it could no longer bring satisfaction to those young artists.

La Japonaise

Claude Monet, 1875
Oil on canvas, 232.4 x 142.2 cm
Museum of Fine Arts, Boston, Massachussets

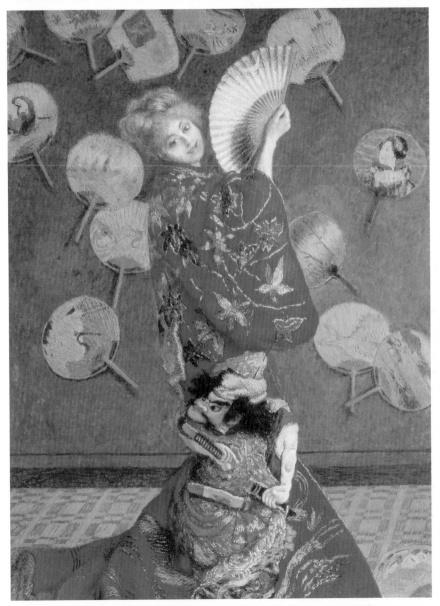

The Parisian Theodore Rousseau had traveled in his childhood with his father around France and fallen in love with nature. His biographer wrote, "one day, alone, without warning anyone, he buys colours and brushes and goes to Montmartre, to the foot of the old church and there he starts to paint what he sees in front of him, the monument, the cemetery (and) the trees (…). In a few days he finished

In a Café
also called The Absinthe

Edgar Degas, 1875-1876
Oil on canvas, 92 x 68 cm
Musée d'Orsay, Paris

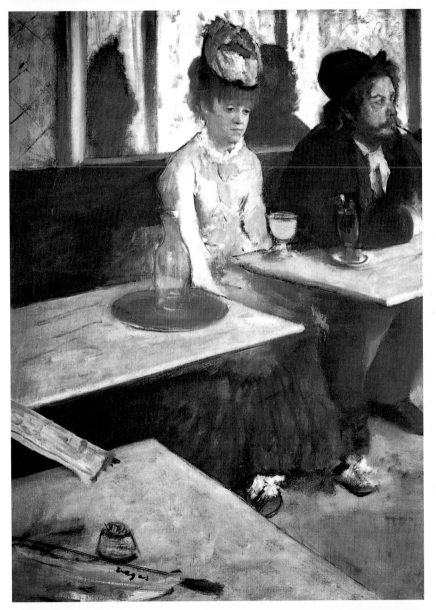

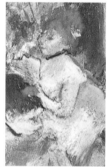

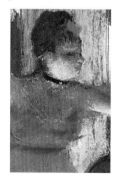

an exact study with an assured and a very natural tone. This was the beginning of his vocation as an artist (…)" (A. Sensier, *T. Rousseau,* Paris, 1872, p. 17). He began painting "what he saw in front of him", particularly in Normandy. Before any of the future Impressionists were even born, Rousseau's name became famous thanks to the 1833 Salon.

Concert in the "Café des Ambassadeurs"

Edgar Degas, ca. 1876
Monotype, 37 x 27 cm
Musée des Beaux-Arts, Lyon

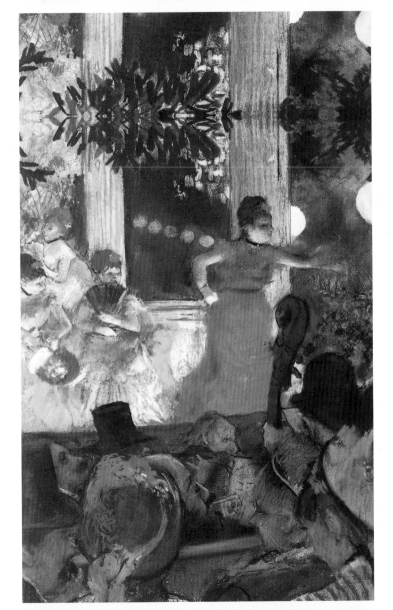

This painting, *View on the Outskirts of Granville* (The Hermitage Museum, St. Petersburg), was impressive because of its theme: an insignificant rural motif. A contemporary critic of Rousseau wrote that this landscape "is one of the truest and the warmest toned paintings that the French school has ever produced." (Sensier, op. cit, p. 38).

Madame's Birthday

Edgar Degas, 1876
Monotype, 11.5 x 15.9 cm
Musée Picasso, Paris

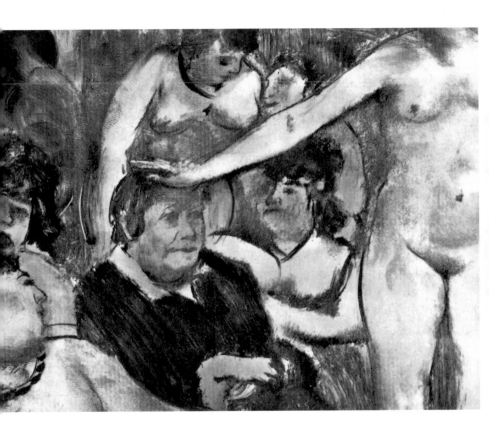

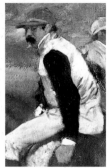

At the edge of the forest of Fontainebleau, Rousseau discovered the village of Barbizon. There he was joined by his friend Jules Dupré and a Spanish painter, Narcisse Virgile Diaz de la Pea. Constant Troyon, Rousseau's friend, also frequently painted in Barbizon. In the late 1840s, Jean-François Millet, a painter of rural France, settled in Barbizon.

At the Races, Gentlemen Jockeys

Edgar Degas, 1876-1877
Oil on canvas, 66 x 81 cm
Musée d'Orsay, Paris

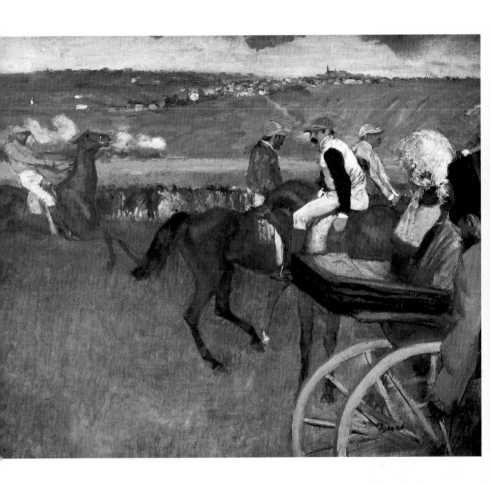

Thus, the group of landscapists was formed. They were later known as the Barbizon school painters. However, outside in the forest, the Barbizon landscapists only painted the sketches, on which they later composed their paintings in their studios. Charles-François Daubigny went even further. For some time he worked with them in Barbizon.

Corner of the Garden at Montgeron

Claude Monet, 1876-1877
Oil on canvas, 71 x 61 cm
The Hermitage, Saint-Petersburg

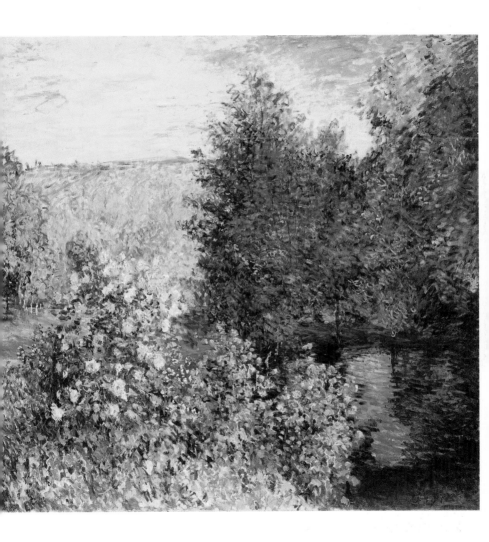

129

He settled in Auvers-sur-Oise and built himself a floating studio which he named 'Bottin'. While sailing along the river, the artist stopped at any place that he liked and painted the scene directly in front of him. Such technique allowed him to discard the traditional composition and to build up the colour of his painting on the observation of nature.

Pond at Montgeron

Claude Monet, 1876-1877
Oil on canvas, 172 x 193 cm
The Hermitage, Saint-Petersburg

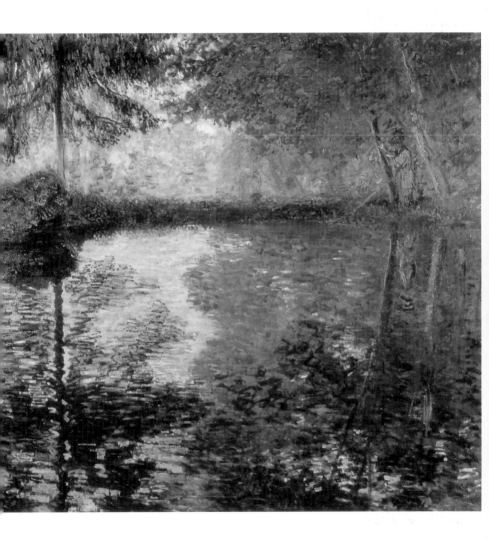

Later it was Daubigny, a member of the Salon jury, who supported the future Impressionists. Camille Corot, who lived in the village of Ville-d'Avray not far from Paris, was perhaps the closest to the Impressionists. With his typical simplicity, Corot painted the ponds near his house, the reflections of willow trees in them, and the shaded pathways steering away to the depth of the forest.

A Road in Louveciennes

Camille Pissarro, 1877
Oil on canvas, 60 x 73.5 cm
Musée d'Orsay, Paris

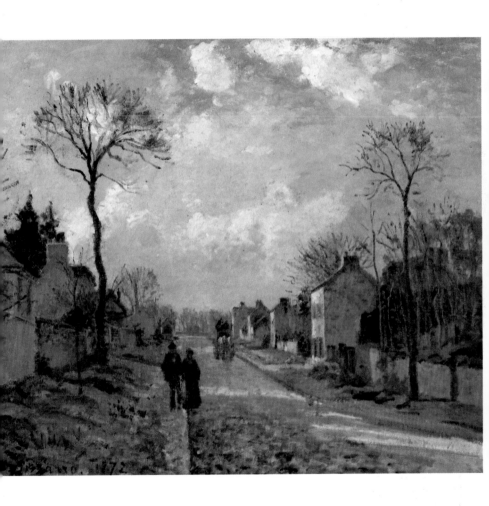

Even if his landscape was reminiscent of his memories of Italy, Ville-d'Avray was recognizable in his paintings. Nobody felt nature quite like Corot did. Within the limits of one green and grey colour, he played with the subtlest transfers of light and shadow. In Corot's art, the colour was secondary. The tones created the impression of mist and sad, lyrical mood that gave his landscapes that liveliness and vibration which the Impressionists tried to attain.

The Red Roofs
Village Corner, Winter Effect

Camille Pissarro, 1877
Oil on canvas, 54.5 x 65.6 cm
Musée d'Orsay, Paris

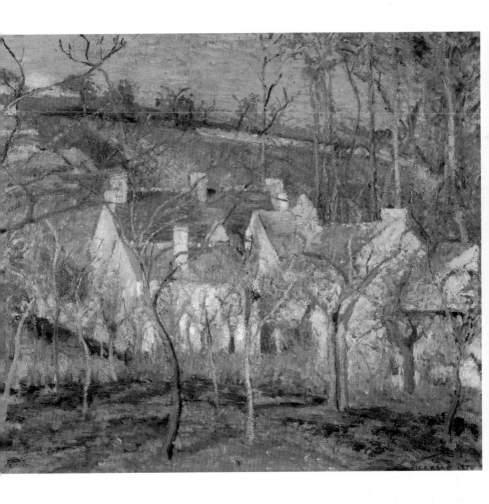

There were two masters among the older contemporaries of the Impressionists who played a critical part in the forming of their system and techniques: Eugene Delacroix and Gustave Courbet. Delacroix showed them that the shadows could be coloured, that the colours could change depending on the colour that is next to it, and that there was no white in nature: the whites are always coloured with hints of reflexions.

The Saint-Lazare Station

Claude Monet, 1877
Oil on canvas, 75 x 104 cm
Musée d'Orsay, Paris

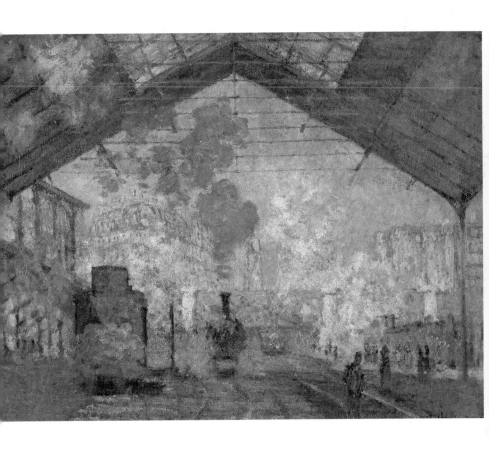

Of course it was possible to see this in some paintings by the Old Masters which Delacroix had studied: Titian, Veronese and Rubens. His paintings nevertheless caused debate. The so-called "romantic battle", the opposition of romantic and classical painters, had not become history yet. At some point, Monet and Bazille even rented a studio at the Place Furstenberg where Delacroix lived, and where they could see him in the garden.

Rue Saint-Denis. Festivities of 30 June 1878

Claude Monet, 1878
Oil on canvas, 76 x 52 cm
Musée des Beaux-Arts et de la céramique
Rouen, France

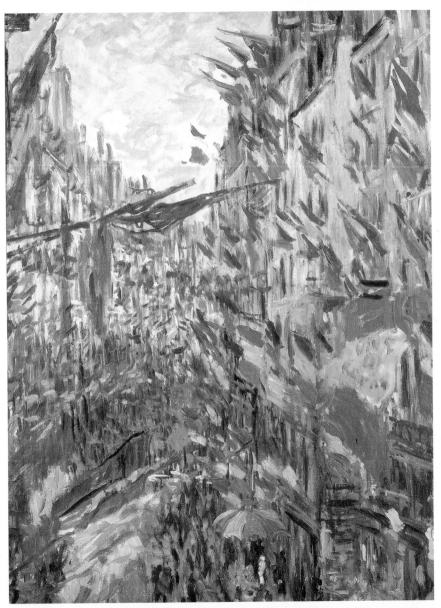

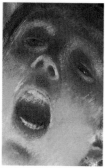

Delacroix taught them to see the wealth of the colours found in nature. Bazille wrote to his parents about Delacroix's art, "you would not believe, how much I learn by looking at his paintings, one session with him is worth one month of work" (François Daulte, *Frédéric Bazille and his time*, Geneva, 1952, p. 92). The Impressionists also met the "realist" Gustave Courbet who depicted the everyday life and who fought the conventional depiction of classical painting.

Singer with a Glove

Edgar Degas, ca. 1878
Pastel on canvas, 52.8 x 41 cm
Fogg Art Museum, Cambridge
Maurice Weinheim collection

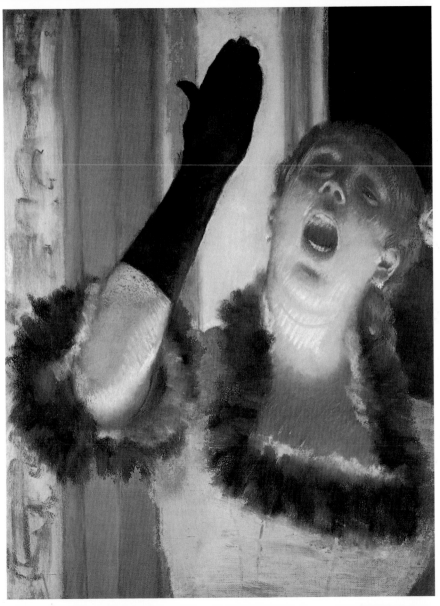

He would frequently put his paintings on the canvas, not with a brush, but with a palette knife, and with solid rough strokes, thus setting an example of freedom of artistic expression unseen before. All this contribution gradually formed and defined Impressionism. A new aesthetical school was born; it now had to be shown to the public.

Dancers in the Wings

Edgar Degas, ca. 1878-1880
Pastel and tempera on paper, 69.2 x 50.2 cm
The Norton Simon Museum of Art, Pasadena

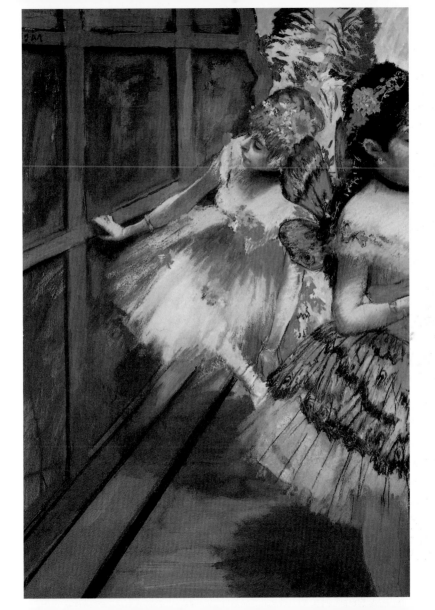

The Impressionists' Exhibition

The time had finally come when the future Impressionists both had to present their concept to the public, and to show the distance that separated them from the official system of art. Furthermore, they wanted to display their works in their own exhibition. But France had only one exhibition of contemporary art at the time – the Salon.

The Poppy Field near Vétheuil

Claude Monet, 1879
Oil on canvas, 60 x 80 cm
E.G. Bührle Foundation, Zürich

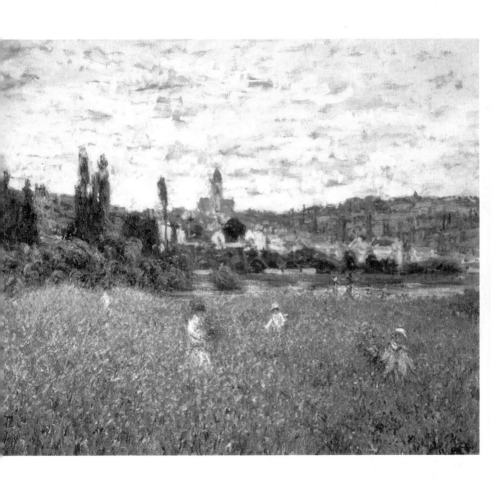

Every artist attempted to get his works displayed in the Salon. It was the only way to get recognition and fame, and therefore was an opportunity to sell one's works. The paramount requirement of the Salon jury was that of a superb artist's professionalism in composition, drawing, anatomy and linear perspective, as well as in the technique of painting.

The Artist's Garden at Vétheuil

Claude Monet, 1880
Oil on canvas, 151.5 x 121 cm
National Gallery of Art, Washington
Alisa Mellon Bruce Collection

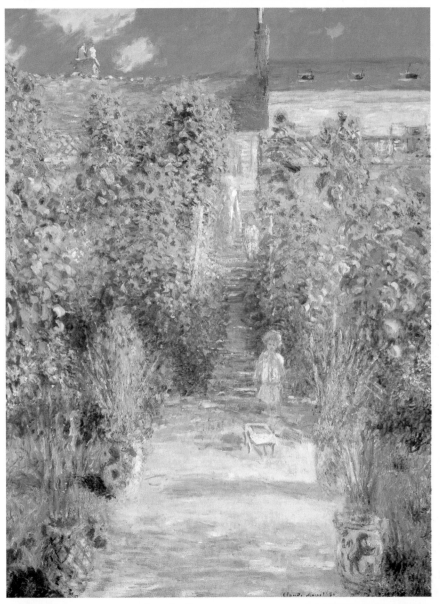

Claude Monet '80

Impeccably smooth bright surfaces created by tiny brushstrokes virtually undistinguishable to the bare eye created a sense of accomplishment in a painting, without which it could not possibly compete with the others. The Salon had no place for depicting real-life scenes, to which the budding Impressionists aspired. The Salon was founded in the eighteenth century by Colbert, Louis XIV prime minister, the exhibition was originally held in Le Salon Carré (the Square Salon) of the Louvre.

Camille on Her Deathbed

Claude Monet, 1879
Oil on canvas, 90 x 68 cm
Musée d'Orsay, Paris

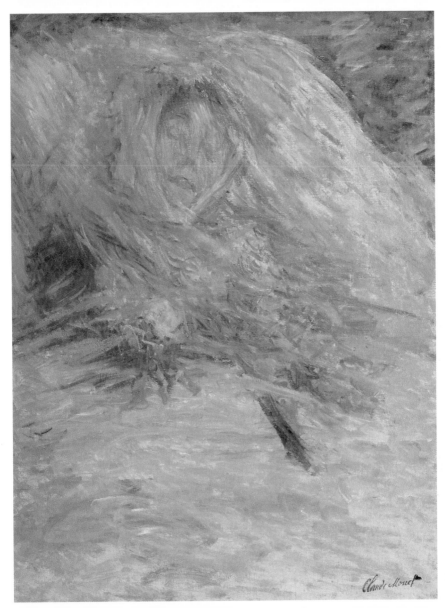

Claude Monet

149

The Salon judges were also members of one of the five academies in France. One of them, the Academy of Fine Arts, appointed the judges. Paradoxically, the professors who judged and accepted paintings and sculptures for the Salon were the same professors who also taught these artists. Furthermore, the selection sometimes became a bargain in which each professor tried to get his student's work to be displayed.

Mademoiselle Lala
at the Cirque Fernando

Edgar Degas, 1879
Oil on canvas, 117 x 77.5 cm
National Gallery, London

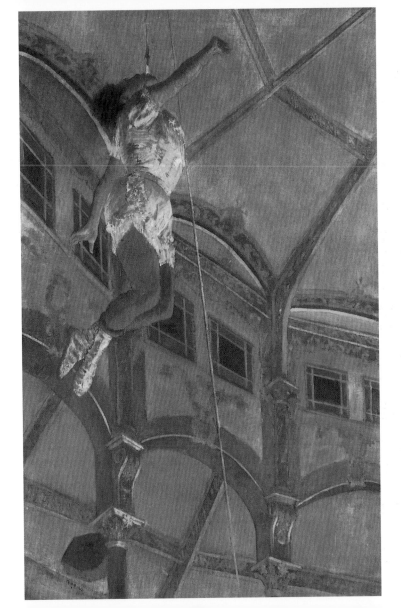

Nevertheless, the Salon's foundations were rather solid, and its traditions went almost unchanged throughout its entire history. Scenes from ancient Greek mythology or from Holy Scriptures contributed to the literary element of the paintings that were deeply embedded in .the history of the Salon.

Bunch of Sunflowers

Claude Monet, 1880
Oil on canvas, 101 x 81.3 cm
The Metropolitan Museum of Art, New York

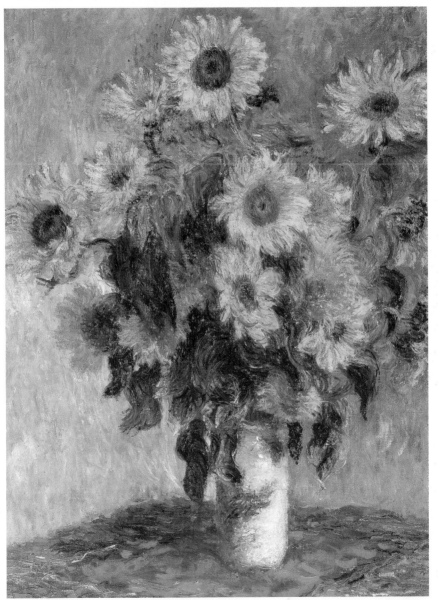

153

What varied was the choice of scene which alternated depending on the preferences of the day. The portraits were traditionally formal; the landscapes were exclusively composed on the basis of the artists' imagination. The Salon had no place for depicting real-life scenes, to which the budding Impressionists aspired.

Ballet (The Star)

Edgar Degas, 1879-1881
Pastel over monotype, 58 x 42 cm
Musée d'Orsay, Paris

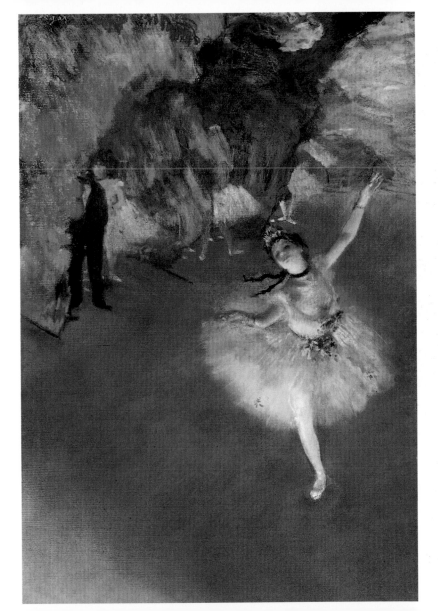

The Salon yet had another tacit requirement: the artists had to please those potential buyers for whom ultimately the artwork was executed. The achievement of the revolutions of the late eighteenth century gave birth to a class of *nouveaux riches*.

Little Dancer Aged Fourteen

Edgar Degas, ca. 1879-1881
Bronze partly coloured, cotton skirt
satin ribbon, wood base, h. 95.2 cm
Musée d'Orsay, Paris

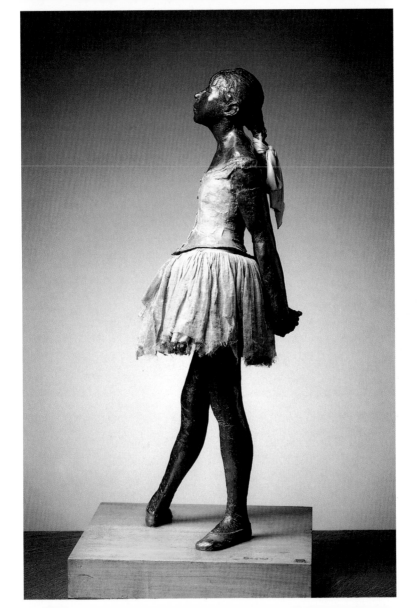

Former merchants who became wealthy in the wave of revolutionary developments were now building luxurious mansions in Paris, purchasing jewellery in the most expensive boutiques in the Rue de la Paix, as well as costly works by artists who had gained their recognition in the Salon. The tastes of those new buyers were rather questionable but the artists of the day had to adjust to them.

The Luncheon of the Boating Party

Auguste Renoir, ca. 1880
Oil on canvas, 129.5 x 172.7 cm
The Phillips Collection, Washington

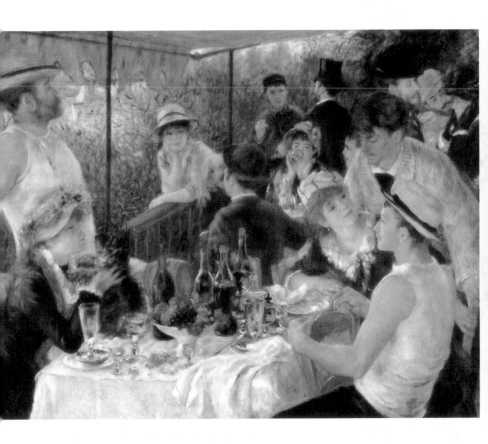

Precisely, in the second half of the nineteenth century, the term "Salon artist" took the meaning of lack of principles and of corruption. This "anyway you please" attitude was the key to commercial success for artists. The mere fact that certain artists displayed their work in the Salon proved their high professionalism.

Lady with a Fan

Auguste Renoir, 1881
Oil on canvas
Sterling and Francine Clark Art Institute
Williamstown

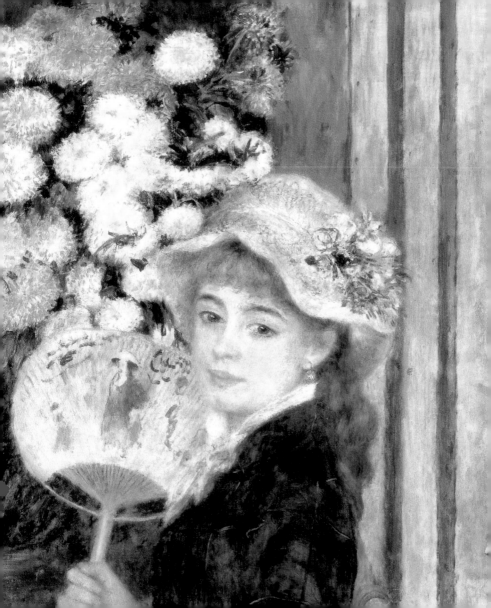

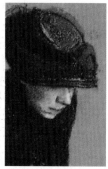

But it is true that these artists could easily adapt their manner of painting or their style. For instance, it was common to see, next to a classical composition in the Salon, another painting by the same artist, composed in the romantic tradition. The continued formal and classical atmosphere of the Salon was considered as a matter of pride which contributed to the Salon's reputation.

Waiting

Edgar Degas, ca. 1882
Pastel on vellum paper, 48.2 x 61 cm
The J. Paul Getty Museum, Malibu
and the Norton Simon Museum, Pasadena

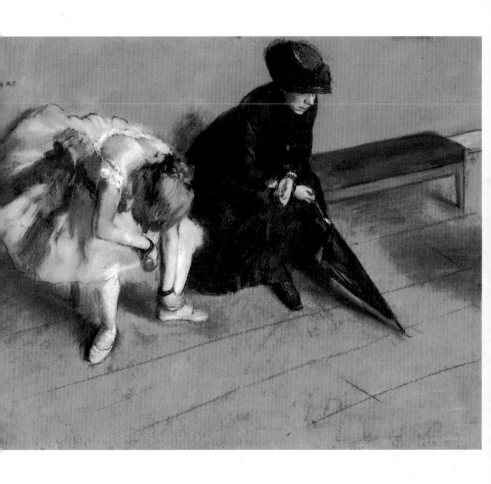

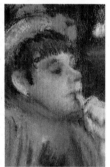

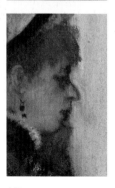

The acknowledged stars of the Salon were mockingly called the "artistes pompiers". The true origin of the phrase was lost, but it was maybe linked to the constant presence of real fire fighters in the Salon halls, or to the paintings of shining polished casks of ancient warriors in the Salon.

Women in a Café

Edgar Degas, 1882
Pastel over monotype
Musée du Louvre, Paris

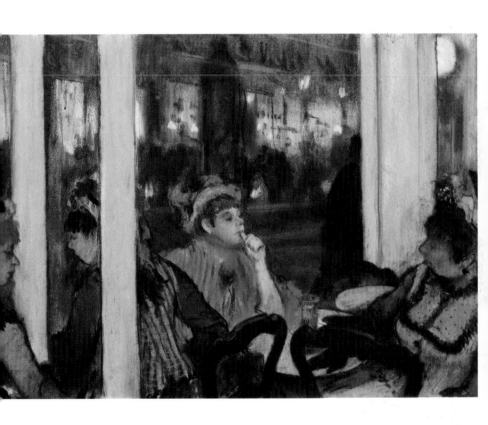

The word was maybe related to the name of Pompeii: the depiction of Pompeian daily life was frequently present in the Salon's historical compositions. One theory links it to the famous phrase of the academician Gerome, who said that it was easier to be an arsonist than a "pompier". The respectable professor meant that artists like himself were engaged in the difficult and noble task of a "pompier".

Dance in the City

Auguste Renoir, 1883
Oil on canvas, 180 x 90 cm
Musée d'Orsay, Paris

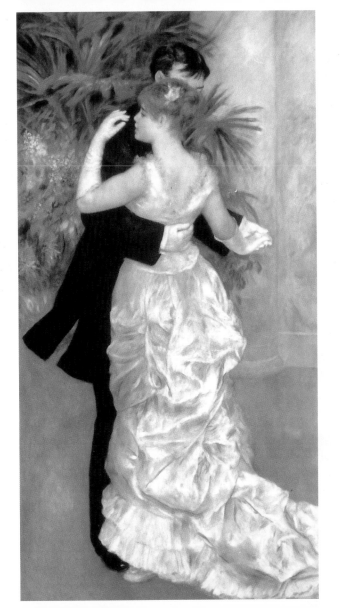

At the same time those who were endangering the foundations of the Salon and the classical system of art in any manner naturally were the arsonists. The four students of professor Gleyre, and Pissarro who joined them became "arsonists" by choice. The classical formalism in art had already caused the painters' protestation in the past.

Dance in the Country
———————————————

Auguste Renoir, 1883
Oil on canvas, 180 x 90 cm
Musée d'Orsay, Paris

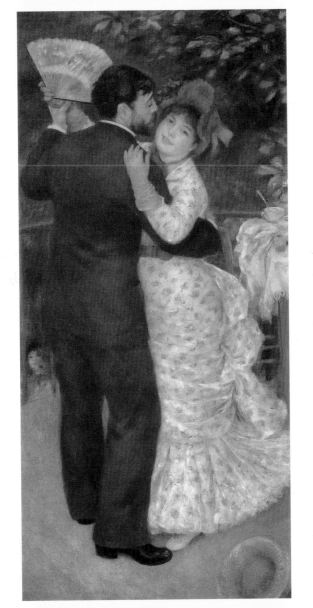

169

Even the great Ingres, a member of the Academy, and a professor for whom defending the classicism in art was a matter of honour, said that the Salon distorted and suppressed the artists' feeling of greatness and of beauty. Ingres admitted that the decision to join the Salon invoked a mercantile attitude driven by desire to get displayed by all means, and that the Salon had turned into an art store.

Etretat, Sunset

Claude Monet, 1883
Oil on canvas, 55.3 x 80.7 cm
Courtesy of the North Carolina Museum of Art, Raleigh

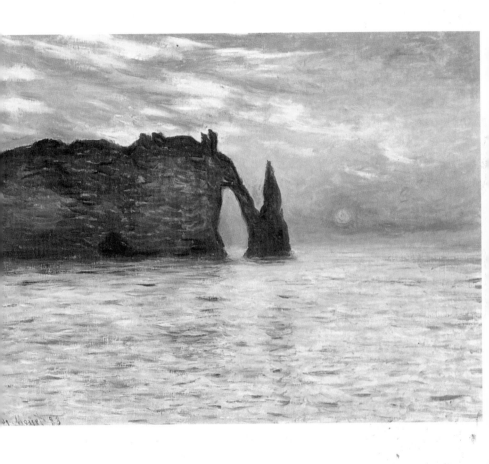

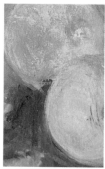

He compared it to a marketplace flooded with an enormous number of art objects and where commerce and not art ruled. At the same time many artists were left out of the exhibition; some were indeed poor professionals while others simply did not comply with the classical requirements and ideas.

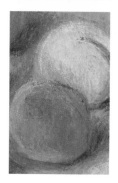

Peaches

Claude Monet, 1883
Oil on canvas, 50.5 x 37 cm
Private collection

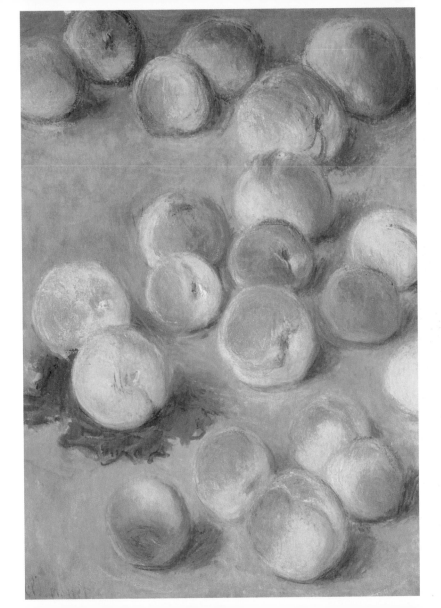

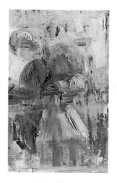

In 1855, only two thousand works out of a total of eight thousand paintings were approved. That year the best paintings by Gustave Courbet were rejected including his *Funeral in Ornans* (Musée d'Orsay, Paris). The members of the Salon jury judged that his artistic trends constituted a threat for French art. Courbet was in fact the first seriously inclined "arsonist".

The Quay at Bougival

Berthe Morisot, 1883
Oil on canvas, 55.5 x 46 cm
Nasjonalgalleriet, Oslo

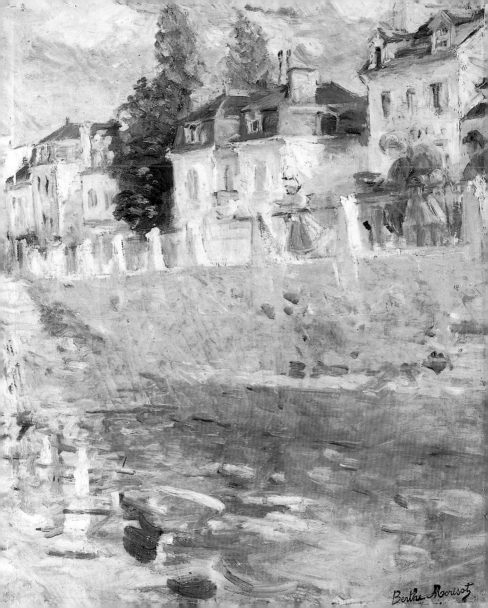

He wrote in the catalogue of his exhibition: "I studied, outside all the systems of mind and, without judgment, the old arts and the modern arts. I did not want to imitate the ones that copy the others (…). To be able to translate morals, ideas, aspect of my epoch, according to my appraisal, one word, to make art alive, is my aim" (Charles Leger, *Courbet*, Paris, 1925, p.62). The Impressionists could have signed under Courbet's statement because, though with different means, they all attempted to attain the same goal.

Bordighera

Claude Monet, 1884
Oil on canvas, 65 x 81 cm
The Art Institute of Chicago, Illinois

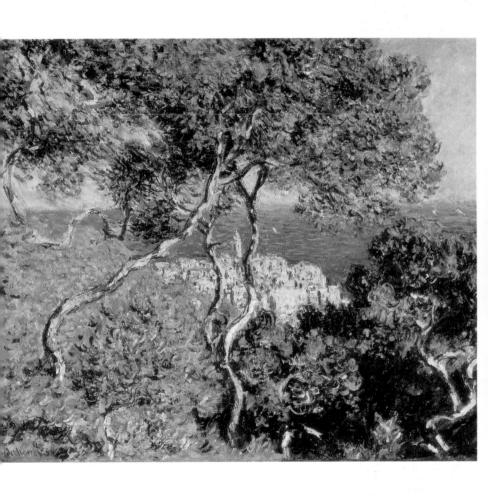

Each of the future Impressionists made an attempt to get his work displayed in the Salon, with unequal success. In 1864, Pissarro and Renoir were fortunate enough to be accepted, even though Renoir considered his *Esmeralda,* that was accepted to the Salon, poor and destroyed the painting as soon as the Salon was finished. In 1865, the works of Pissarro, Renoir and Monet were also accepted into the Salon.

The Sewing Lesson

Berthe Morisot, 1884
Oil on canvas, 59 x 71 cm
Minneapolis Museum of Art, Minneapolis

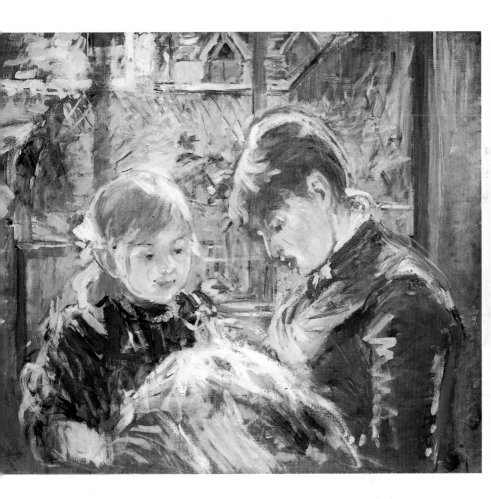

But even their close friends noted their too modest small landscapes, even when they were displayed in the Salon. In 1866, all of their paintings – Monet, Bazille, Renoir, Sisley and Pissarro – were accepted, and Pissarro was reviewed in particular detail by a young writer named Emile Zola. The jury of the 1867 Salon was more rigid with the young artists: they denied Bazille, and only one painting was accepted out of many submitted by Monet.

On the Lake

Berthe Morisot, 1884
Oil on canvas, 60 x 73 cm
Private collection

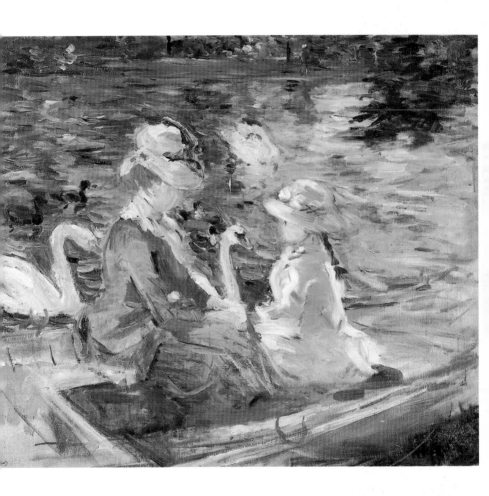

Zola, whose reviews were centered on the young artists as if ignoring the painters of the classical school, wrote to a friend that the judges were outraged by his "Salon" and now closed the doors to everyone who was searching for new ways in painting. But the 1868 Salon included paintings by all five of them – Monet, Renoir, Bazille, Sisley, and Pissarro.

Naked Woman Drying Her Foot

Edgar Degas, 1885-1886
Pastel on paper, 54.3 x 52.4 cm
Musée d'Orsay, Paris

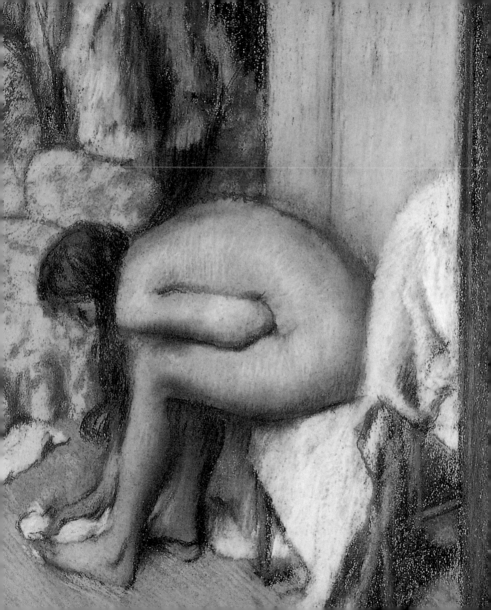

However, their desire to get displayed outside the Salon was growing stronger. It was most likely Courbet's example that inspired them for their own exhibition. Courbet was the first one to do so, setting up an *impromptu* structure in 1865, not far from the *Exposition Universelle*, and entitled "Pavilion of Realism". The exponents were rather varied.

In the "Café des Ambassadeurs"

Edgar Degas, 1885
Pastel, 26.5 x 29.5 cm
Musée d'Orsay, Paris

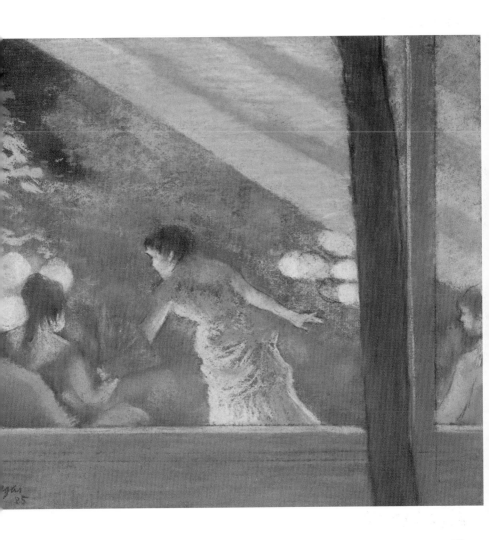

Edgar Degas who joined them at that time managed to attract the interest of his friends: the sculptor Lepic and the engraver de Nittis, who were popular in the Salon. They were joined by Armand Guillaumin, an official of the Orléans Railroad Company, who painted landscapes *en plein air,* and followed them upon the invitation of Pissarro.

Motherhood
———————

Auguste Renoir, 1886
Oil on canvas, 74 x 54 cm
Private collection

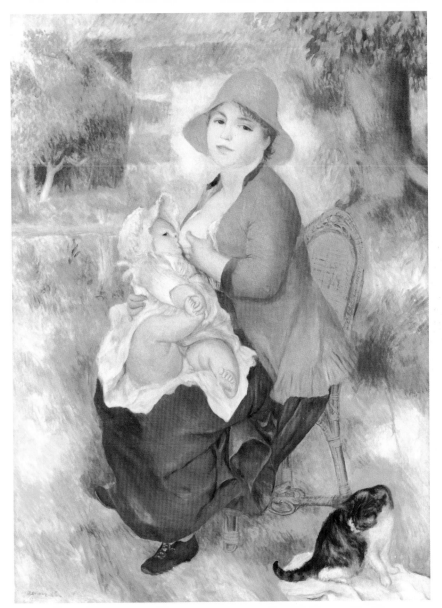

The latter also brought Paul Cézanne from his hometown of Aix-en-Provence to participate in the exhibition. In the spring of 1867 Courbet and Edouard Manet opened their own exhibitions since the Salon judges again declined to accept their paintings into the Salon. But the future Impressionists' friends were concerned about possible outcomes of such exhibitions.

The Rocks at Belle-Ile

Claude Monet, 1886
Oil on canvas, 60 x 73 cm
Ny Carlsberg Glyptotek, Copenhagen

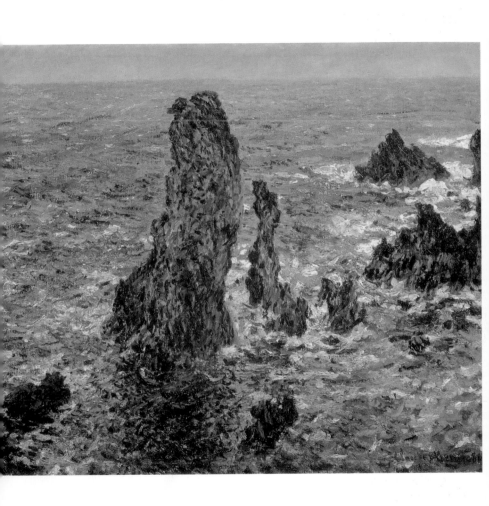

Theodore Duret, a well-known critic, advised them to continue trying to get into the Salon. He believed that it was impossible to become famous through independent group exhibitions. Such exhibitions did not seem attractive for the general public, but only for the artists and their supporters who were already familiar with their work.

Sketch for a Figure
in Open Air (to the left)

Claude Monet, 1886
Oil on canvas, 88 x 131 cm
Musée d'Orsay, Paris

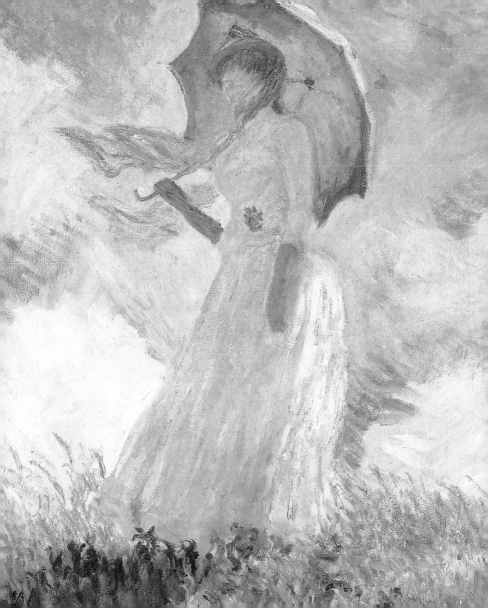

Duret recommended to choose works for the Salon that had a story in line along with the traditional composition, that is to say not too modern in technique but particularly accomplished. In other words, he advised them to try to reach a compromise with the official art. The critic thought it was only way for them to succeed in drawing the public's and the critics' attention to their work.

Sketch for a Figure
in Open Air (to the right)

Claude Monet, 1886
Oil on canvas, 88 x 131 cm
Musée d'Orsay, Paris

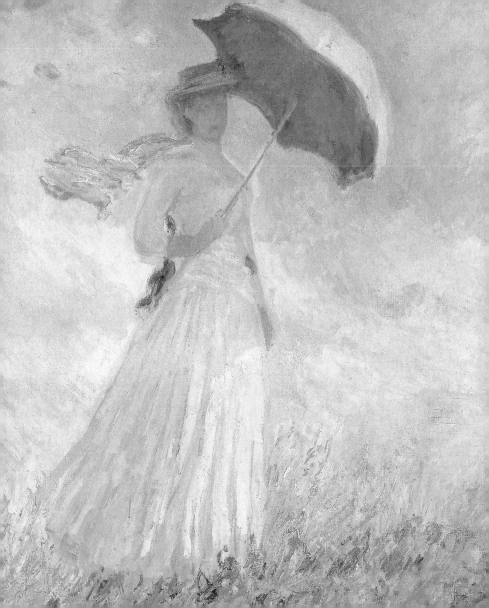

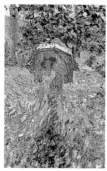

Some of the artists tried to attain such a compromise. These examples were inspiring and the idea of an independent exhibition was not forgotten: it gradually grew. In 1872 Renoir made a huge painting, *Allée cavalière au Bois de Boulogne* (Kunsthalle, Hamburg), which was considered as a formal society portrait.

Under the Poplars, Sunlight Effect

Claude Monet, 1887
Oil on canvas, 74.3 x 93 cm
Staatsgalerie, Stuttgart, Germany

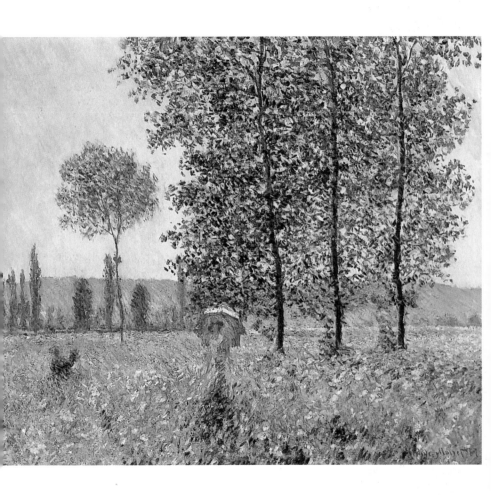

The judges, however, turned the painting down, and it was ultimately displayed in the *Salon des Refusés* (the Salon of the Refused), which re-opened again, just like it did in 1863. Bazille died before the independent exhibition was finally organized. He was killed in 1870 in the Franco-Prussian war.

The Orange Picker

Berthe Morisot, 1889
Pastel, 60 x 46 cm
Musée d'Art et d'Histoire de Provence, Grasse

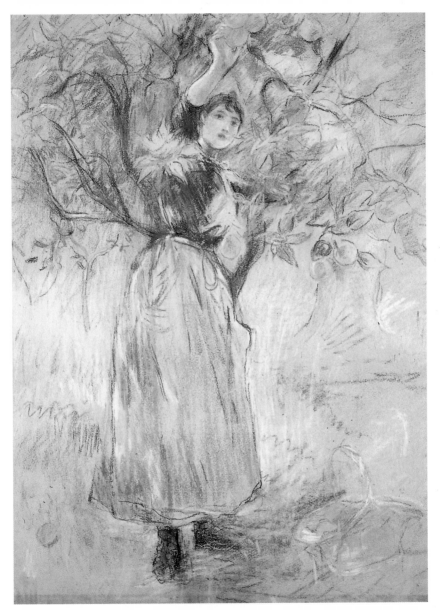

Thus in 1874, the confident and bold Claude Monet became the leader of the group of young artists. He believed that it was through their own exhibition that they would stir some riot and ultimately become successful. The rest of the group agreed with him. It was somewhat intimidating to display independently, and they tried to invite as many friends to join them as they possibly could.

Poplars, White and Yellow Effects

Claude Monet, 1891
Oil on canvas
The Philadelphia Museum of Art
Philadelphia, Pennsylvania

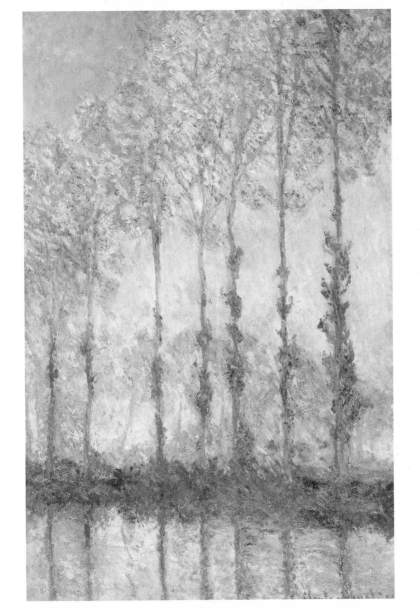

As a result, the exponents were rather varied. Besides a few supporters of the new manner of painting, some of the artists who joined them were rather distant in their technique. Edgar Degas who joined them at that time was very active in bringing together various artists for participation in the exhibition. He managed to attract the interest of his friends, one of whom was the sculptor and engraver Lepic who was popular in de Nittis Salon.

Haystacks, End of an Autumn Day

Claude Monet, 1891
Oil on canvas
The Art Institute of Chicago

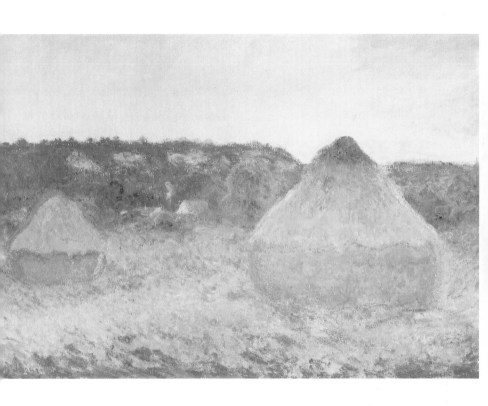

Degas also tried to convince the brilliant formal painter James Tissot and his friend Legros, who lived in London, to join them but he did not succeed. Following the invitation of Pissarro, Armand Guillaumin, an official of the Orleans Railroad Company, who also painted landscapes *en plein air*, joined them.

Girl Playing Piano
—————————

Auguste Renoir, 1892
Oil on canvas, 116 x 90 cm
Musée d'Orsay, Paris

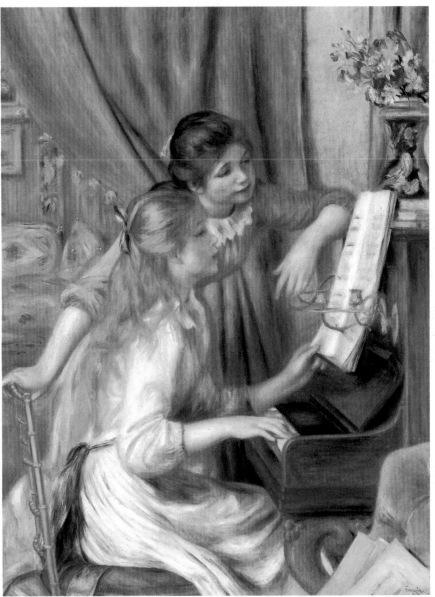

Pissarro also brought Paul Cézanne, who had come from his hometown of Aix-en-Provence, to participate in the exhibition. The young man had already demonstrated in his first works that not only had he kept the distance from the formal tradition, but he also did not share the viewpoints of the Impressionists.

Tree-Lined Avenue near Moret

Alfred Sisley, 1892
Oil on canvas, 60 x 73 cm
Musée Masséna, Nice

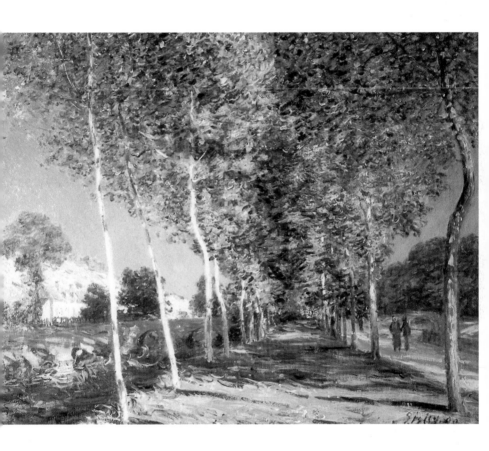

Perhaps it was his participation that influenced the decision of Edouard Manet, who came out to be the most important exhibitor of the group. According to his contemporaries, Manet said that he would never want to be displayed in the same exhibition as Cézanne,

After the Bath

Edgar Degas, 1890-1893
(dated 1885 by a later hand)
Pastel on tracing paper, 66 x 52.7 cm
The Norton Simon Museum of Art, Pasadena

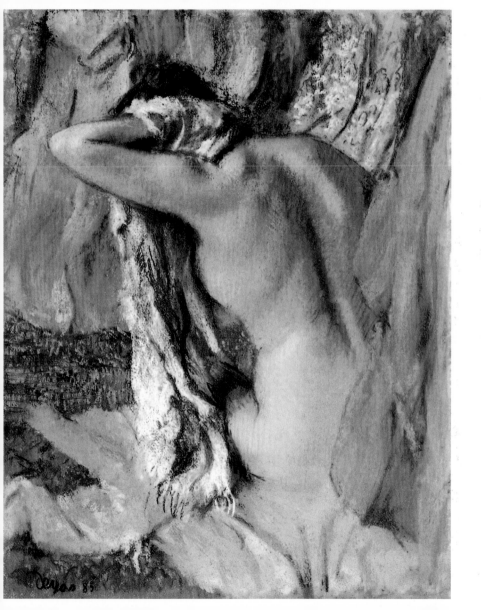

but it was also possible that Manet simply preferred another way of getting his art known. Claude Monet used to say that Manet tried to bring him and Renoir into continued attempts to win over the Salon. He believed that the Salon represented the best and the most worthy battlefield.

Blue Dancers

Edgar Degas, ca. 1893
Oil on canvas, 85 x 75.59 cm
Musée d'Orsay, Paris

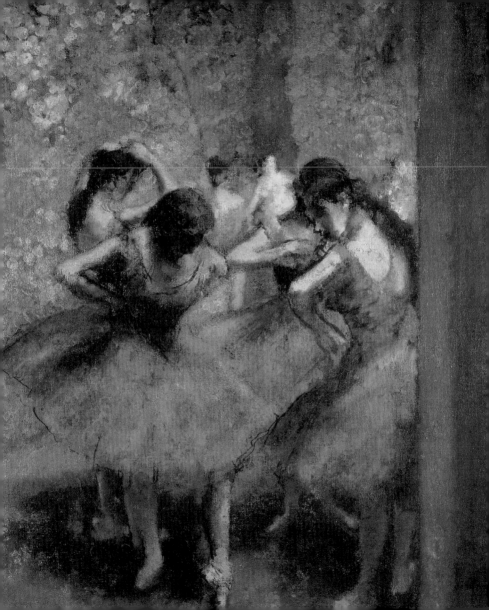

Degas, however, believed that it was Manet's vanity that stood in his way. He said, "the realist movement has no longer need to fight against the others. It exists, it has to show itself as apart. One needs a realist salon. Manet does not understand that." (*Manet,*

The Bridge at Moret

Alfred Sisley, 1893
Oil on canvas, 73.5 x 92.5 cm
Musée d'Orsay, Paris

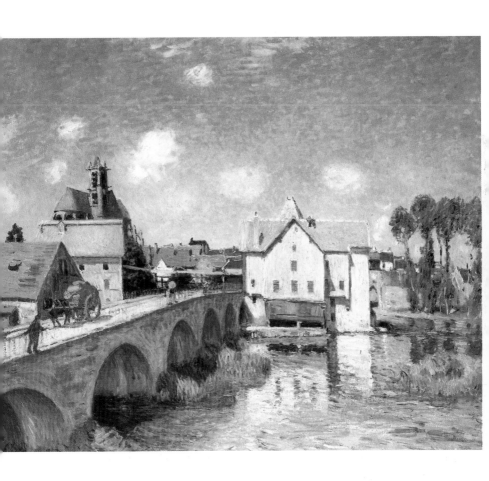

Paris, 1983, Editions Réunion des musées nationaux, p. 29) As a result, neither Manet, nor his best friend Henri Fantin-Latour displayed their works together with the young artists. The idea of an independent exhibition intimidated Corot, who treated their art well and talked a young landscape painter Antoine Guillemet out of participating in it.

The Portal, Morning Fog

Claude Monet, 1893
Oil on canvas, 100 x 65 cm
Museum Folkswang, Essen, Germany

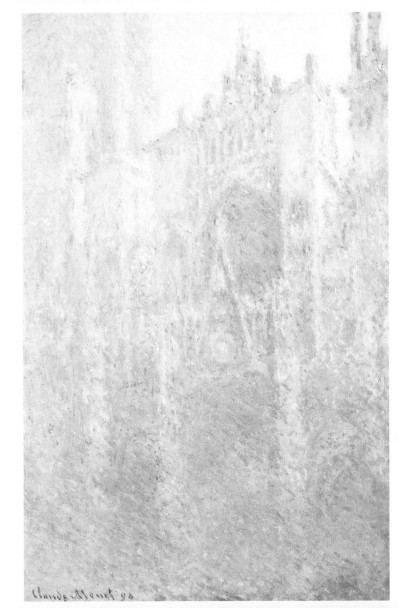

Claude Monet 94

However, he failed to convince a young and bold lady, Berthe Morisot. She was a student of Corot and Manet, and at that time she had also joined the future Impressionists. However, setting up an independent exhibition turned out to be far from easy: they needed money and useful connections. Finding a suitable location for the exhibition was one of the challenging tasks they had to face.

Rouen Cathedral in the Evening

Claude Monet, 1894
Oil on canvas, 100 x 65 cm
Pushkin Museum of Fine Arts, Moscow

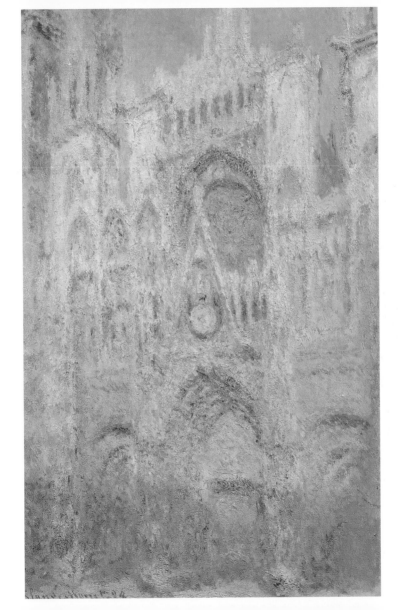

Leasing galleries to young artists was risky – not only were they unknown to the public, but they were also attempting to oppose the official Salon. In April 1867 Frédéric Bazille wrote to his parents, "we solved the difficulty of renting an exhibition place. We found a big studio where we can display any number of our works each year. We invite the painters we

The Church in Moret, Rainy Morning

Alfred Sisley, 1894
Oil on canvas, 73 x 60 cm
Birmingham Museum Art Gallery, Birmingham

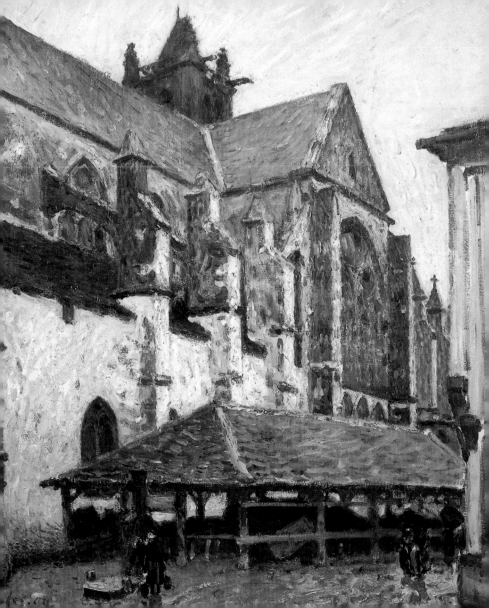

appreciate to send us paintings. Courbet, Corot, Diaz, Daubigny, and a lot of others promised to send us paintings and agreed on a lot of our ideas. There is Monet who is stronger than all of us, and we are successful. You will see that people will talk of us." (F. Daulte, *Frédéric Bazille et son temps*, Geneva, 1952, p. 58).

Winter Landscape in Sandviken

Claude Monet, 1895
Oil on canvas, 37 x 52.5 cm
The Latvian Republican Museum
or Foreign Art, Riga

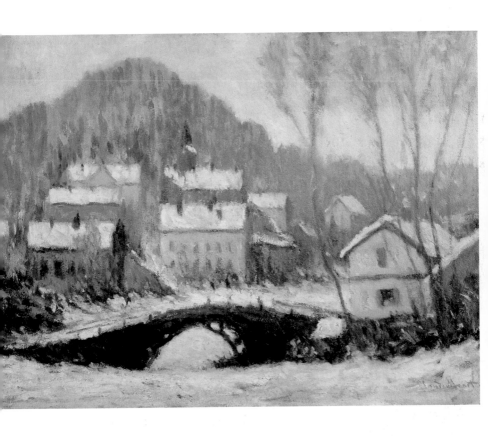

A month later Bazille wrote to his father, "I spoke to you about a project of some young people, who decided to hold an independent exhibition. We worked as much as possible, and we succeeded in gathering an amount of 25 000 francs. But that is not sufficient. So we are forced to sacrifice what we wanted to do" (F. Daulte, op. cit., p. 58.)

The Morning Bath (The Baker's Wife)

Edgar Degas, 1895
Pastel on paper, 70 x 43 cm
The Art Institute of Chicago

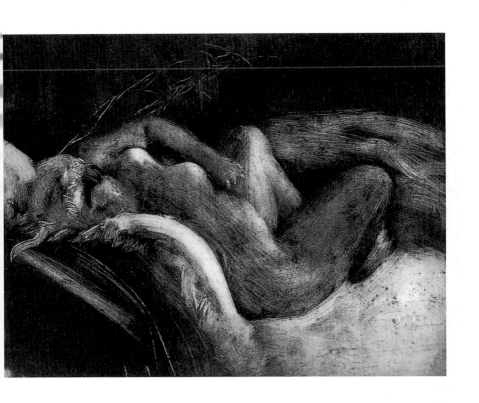

Later Claude Monet recalled that the situation was resolved quite unexpectedly. According to Monet, "Nadar, the great Nadar, who is good like bread, will let us use the local gallery (…)". For the exhibition, they pulled together one hundred and sixty-five works by twenty-nine rather varied artists.

Self-Portrait

Camille Pissarro, 1903
Oil on canvas, 41 x 33.3 cm
Tate Gallery, London

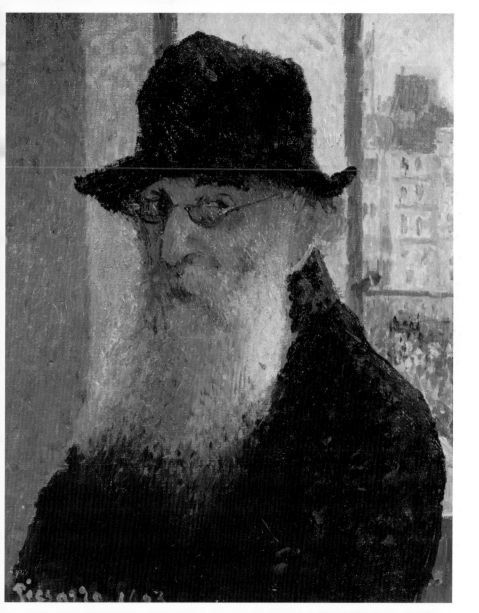

Together with the works of the four students of Gleyre, the exhibition included paintings of Edgar Degas, Berthe Morisot, Paul Cézanne, Felix Braquemond, Zacharie Astruc, Eugene Boudin, and Ludovic Napoleon Lepic. One of the nineteenth-century historians explained that Nadar was known everywhere.

The Branch of the Seine at Giverny, Fog

Claude Monet, 1897
Oil on canvas, 89 x 92 cm
North Carolina Museum of Art
Raleigh, North Carolina

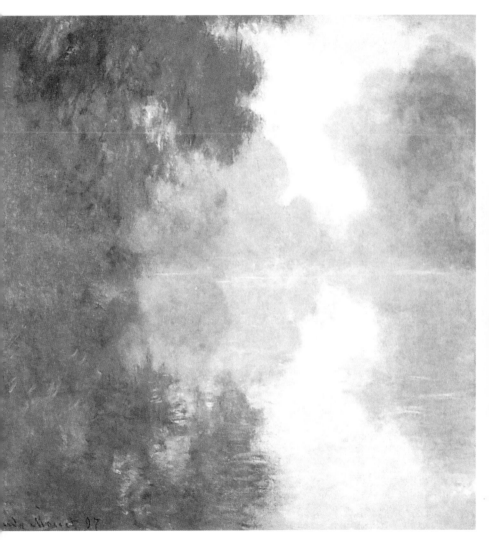

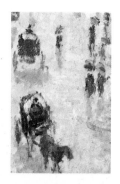

He was known in London as well as in Paris, in Australia as well as in Europe. Nadar was the pen name of Gaspard Felix Tournachon, a journalist, writer, and cartoonist. He also was a wonderful photographer who made photo portraits of many of his great contemporaries including Alexander Dumas, Georges Sand, Charles Baudelaire, Eugene Delacroix, Honoré Daumier, Gustave Doré, Giacomo Meyerbeer, Charles Gounod, Richard Wagner, Sarah Bernard and many others.

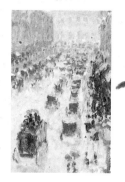

Place du Théâtre français, Paris, Rain

Camille Pissarro, 1898
Oil on canvas, 73.6 x 91.4 cm
Institute of Fine Arts, Minneapolis

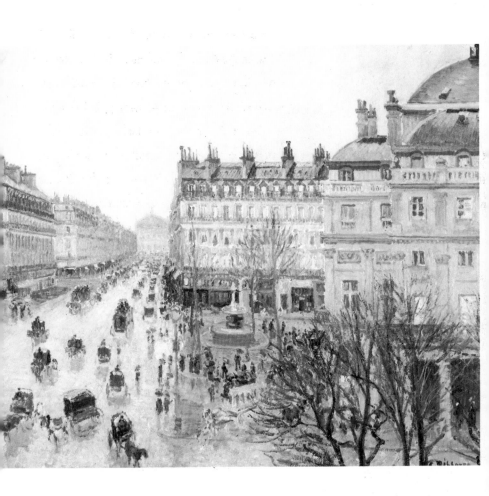

He also was a courageous airman. During the Franco-Prussian war Nadar flew over German troops, getting mail out of besieged Paris, and in 1871 he took Gambetta out of the city on a balloon. Nadar was the first to make bird's eye view aerial photos of Paris, taken from his balloon, and he was the first who took pictures of the Parisian catacombs that were discovered in mid-nineteenth century.

Woman with a Towel

Edgar Degas, 1898
Pastel on papier, 95.4 x 75.5 cm
The Metropolitan Museum of Art
New York, H.O. Havemeyer collection

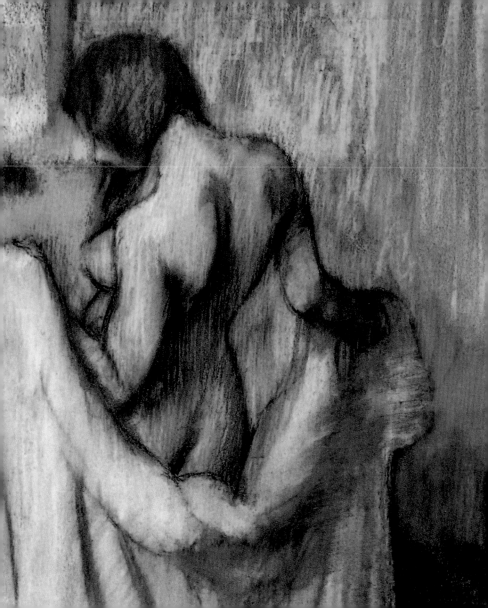

The photo studio that Nadar offered to the future Impressionists was located in the center of Paris, on the second floor of number 35 of the Boulevard des Capucines. But there were no Salon-like spacious halls. Nevertheless, according to the critic Philippe Burty, the lounges on the walls of which a brown-red wool was tightly fixed were extremely favorable for paintings.

White Water Lilies

Claude Monet, 1899
Oil on canvas
Pushkin Museum of Fine Arts, Moscow

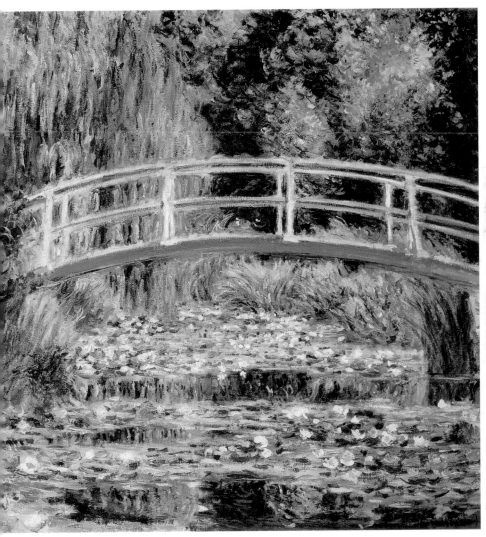

For the exhibition they collected one hundred and sixty-five works, representing twenty-nine rather varied artists. Along with the works of four of Gleyre's students, the exhibition included paintings of Edgar Degas, Berthe Morisot and Paul Cézanne.

The engraver Felix Braquemond, Edouard Manet's friend Zacharie Astruc, Claude Monet's older friend, a landscapist from Le Havre, Eugène Boudin, Degas' friend, the sculptor and engraver Ludovic Napoleon Lepic also joined them.

Pond with Water Lilies

Claude Monet, 1900
Oil on canvas, 89.2 x 92.8 cm
Museum of Fine Arts, Boston

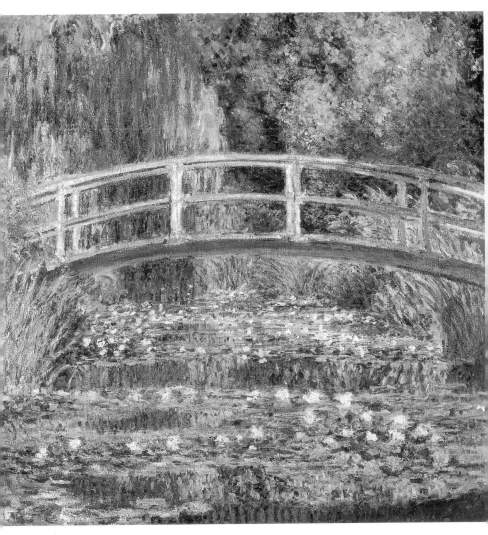

A very formal society painter, Joseph de Nittis, eventually accepted Degas and displayed his works. The names of other participants in the first exhibition did not mean much to their contemporaries and did not leave a significant trace in the history of art.

The Tuileries Gardens in Rain

Camille Pissarro, 1899
Oil on canvas, 65 x 92 cm
Ashmolean Museum, Oxford

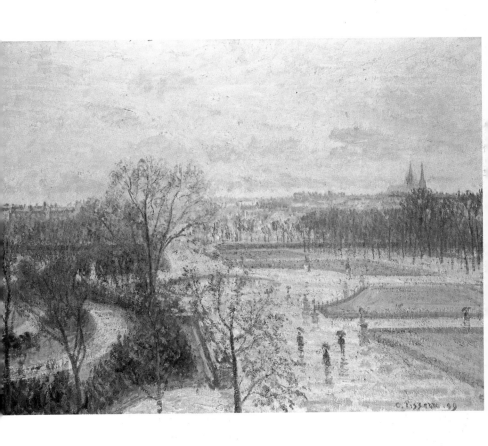

235

Degas suggested to name their union "Capucin", because of the name of the boulevard. The name was neither challenging, explicitly political nor anti-Salon.

They, therefore, adopted the name "Anonymous society of artists, painters, sculptors, engravers, etc."

Water Lilies

Claude Monet, 1903
Oil on canvas, 81 x 100 cm
Dayton Art Institute, Dayton, Ohio

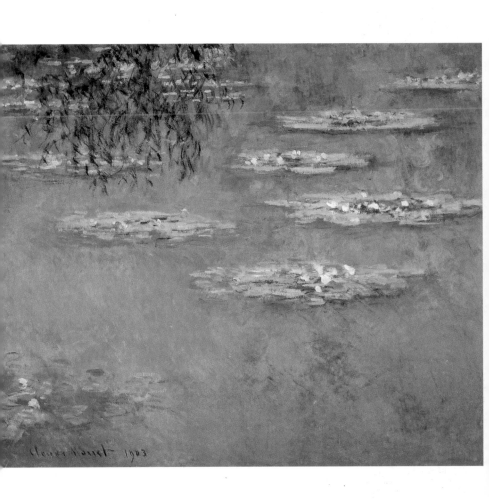

Claude Monet 1903

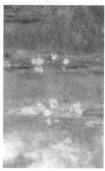

According to Philippe Burty, "the group thus offers to seek a discussion with very recognizable personal aims, aims of common art in the conduct, the return of a large light of *plein air*, in the sentiment, the clarity of the first sensation" (Venturi, op. cit., v. 2, p. 288). However, all these qualities found expression in the art of only those few artists who became known in history as the Impressionists.

Water Lilies, Water Landscape, Clouds

Claude Monet, 1903
Oil on canvas, 73 x 100 cm
Private collection

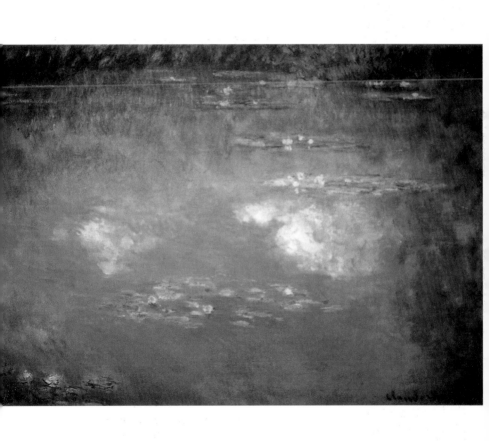

Important dates:

1830s: Formation of the Barbizon group, the Impressionists' predecessor, in which figured Jules Dupré, Virgile Diaz de la Peña, Constantin Troyon, Jean-François Millet, Charles-François Daubigny and Camille Corot.

1833: The painting of Théodore Rousseau, a member of the Barbizon group, *View on the Outskirts of Granville*, is displayed in the Salon.

Seagulls, The Thames in London
The Houses of Parliament

Claude Monet, 1904
Oil on canvas, 81 x 92 cm
Pushkin Museum of Fine Arts, Moscow

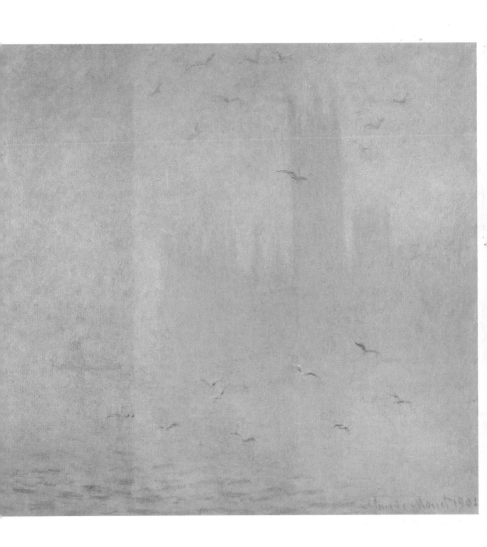

1860: Formation of the group of Impressionists.

1862: Monet, Bazille, Sisley and Renoir start studying in the free studio of Professor Charles Gleyre.

1863: Monet, Bazille, Sisley and Renoir leave the studio of Professor Charles Gleyre. Manet paints *Luncheon on the Grass,* marking a return to nature.

An Ode to Flowers

Auguste Renoir, 1909
Oil on canvas, 46 x 36 cm
Musée d'Orsay, Paris

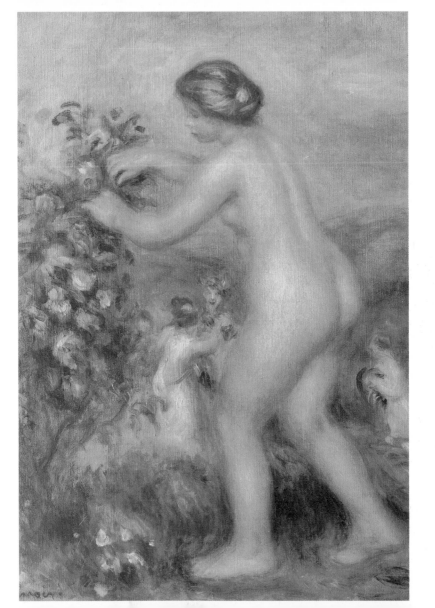

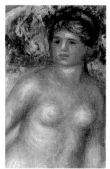

1864: Pissarro and Renoir are accepted into the Salon.

1865: Pissarro, Renoir and Monet are accepted into the Salon. Courbet organizes an *impromptu* (a personal exhibition) called the *Pavillon du Réalisme,* where Degas, de Nittis, Cézanne, Lepic and Guillaumin are displayed.

1866: Monet, Bazille, Sisley, Pissarro and Renoir are accepted into the Salon.

The Judgement of Paris

Auguste Renoir, ca. 1913-1914
Oil on canvas, 73 x 92.5 cm
Museum of Art, Hiroshima

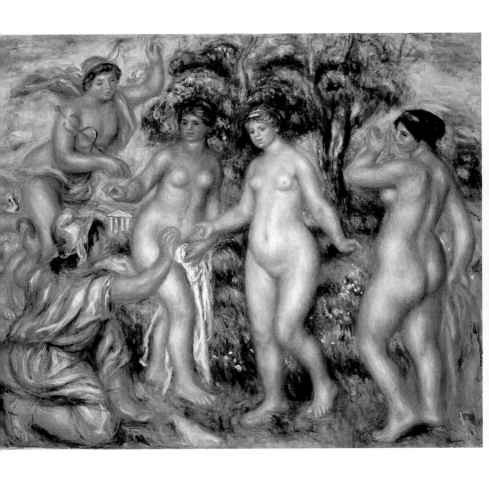

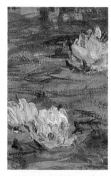

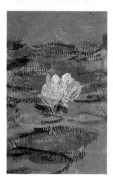

1867: Bazille is refused into the Salon. Courbet and Manet open their own exhibition.

1868: Monet, Bazille, Sisley, Pissarro and Renoir are accepted into the Salon.

1872: Renoir's painting, *Allée cavalière au Bois de Boulogne,* is refused into the Salon and is displayed at the *Salon des Refusés.*

1874: Monet paints *Impressions, Sunrise.* The term *Impressionism* is born. The now-called Impressionists paint outdoor, *en plein air.*

Water Lilies

Claude Monet, 1915
Oil on canvas, 160.7 x 180.7 cm
Portland Art Museum, Portland, Oregon

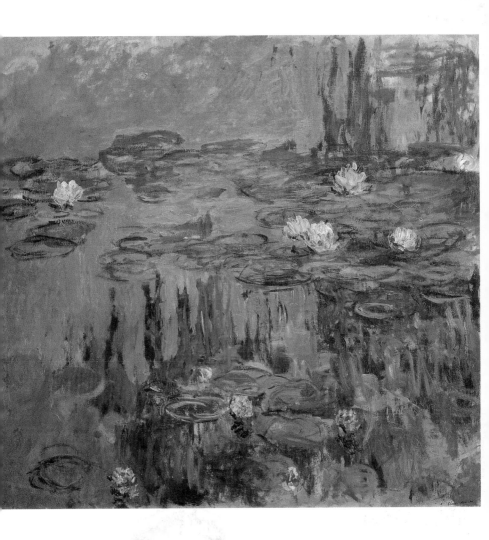

Index